**Exhibition
Catalogue**

Past Things
and Present

Past Things and Present:
Jasper Johns
since 1983

Joan Rothfuss Walker Art Center, Minneapolis

This publication and exhibition are dedicated to the memory and spirit of Kenneth Dayton (1922–2003), a much-loved patron whose devotion to the Walker Art Center will be long remembered. He and his wife, Judy, have for years supported the Walker's interest in Jasper Johns and the extraordinary creativity of his work in all media.

Published on the occasion of the exhibition
Past Things and Present: Jasper Johns since 1983,
curated by Joan Rothfuss for the Walker Art Center.

Walker Art Center
Minneapolis, Minnesota
November 9, 2003–February 14, 2004

Greenville County Museum of Art
Greenville, South Carolina
March 7–May 30, 2004

Scottish National Gallery of Modern Art
Edinburgh, Scotland
July 10–September 19, 2004

IVAM Institut Valencià d'Art Modern
Valencià, Spain
October 7, 2004–January 2, 2005

Irish Museum of Modern Art
Dublin, Ireland
February–May 2005

Past Things and Present: Jasper Johns since 1983 is
made possible by generous support from Judy and
Kenneth Dayton, Martha and Bruce Atwater, Margaret
and Angus Wurtele, The Broad Art Foundation, and the
Fifth Floor Foundation.

The exhibition catalogue is made possible in part by
a grant from the Andrew W. Mellon Foundation in
support of Walker Art Center publications.

Major support for Walker Art Center programs is pro-
vided by the Minnesota State Arts Board through an
appropriation by the Minnesota State Legislature,
The Wallace Foundation, the Doris Duke Charitable
Foundation through the Doris Duke Fund for Jazz
and Dance and the Doris Duke Performing Arts
Endowment Fund, The Bush Foundation, Target
Stores, Marshall Field's, and Mervyn's with support
from the Target Foundation, The McKnight Foundation,
General Mills Foundation, Coldwell Banker Burnet,
the Institute of Museum and Library Services, the
National Endowment for the Arts, American Express
Philanthropic Program, The Regis Foundation, The
Cargill Foundation, 3M, Star Tribune Foundation, U.S.
Bank, and the members of the Walker Art Center.

Lenders to the Exhibition
Douglas S. Cramer
Judy and Kenneth Dayton
Barbaralee Diamonstein-Spielvogel
 and Carl Spielvogel
Anthony and Anne d'Offay
Larry Gagosian
Philip and Beatrice Gersh
Lenore S. and Bernard A. Greenberg
Greenville County Museum of Art
Jasper Johns
Barbara and Richard Lane
Anne Marie Martin
The Museum of Fine Arts, Houston
Dr. Paul and Dorie Sternberg
Sarah Taggart
Walker Art Center
Whitney Museum of American Art
Three private collections

Contents

Director's Foreword

Jasper Johns is a given in American art: someone whose work has been so crucial and constant a presence that its importance and influence almost go without saying. Since his startling debut in 1958, his paintings, drawings, and prints have explored both the ardor in and arduous nature of art-making, perception, memory, and absence with an unpretentious historical reach. As Bruce Nauman once said, "I loved de Kooning's work, but Johns was the first artist to put some intellectual distance between himself and his physical activity of making paintings."[1] Challenging his own habits of mind and vision by constantly reworking his images, he signals the viewer's own intellectual and emotional journey through pictorial puzzles that sometimes span decades, and through his command of a full range of touches, from fragile to brusque. Gray seems a perfect palette for him as it contains all colors and none, skirts absolutes, and allows for subtle displays of painterly grace. For many—myself included—the experience of standing in front of paintings by Johns has been an exhilarating blend of knowing and discovering that perhaps mimics the artist's own process.

The Walker Art Center is privileged to have a long-standing relationship with Johns that has included several significant exhibitions and acquisitions. Perhaps most extraordinary was the gift, in 1989, of a complete archive of his graphic work: more than 300 prints by one of the most inventive masters of the medium. This remarkable acquisition was made possible by Judy and Kenneth Dayton, longtime Walker patrons and admirers of Johns' work, and includes a commitment to add a copy of each new print as it is made. Our permanent collection also includes the 1960 bronze *Flashlight* and the 1990 painting *Green Angel*, which is the subject of an essay in this volume, and the important canvas *Flags* (1965) has been on loan to the Walker through the artist's generosity since 1988. In 2000, we acquired the set elements for the 1968 dance *Walkaround Time*, designed by Johns for his friend Merce Cunningham's company. Consisting of seven plastic pillows painted with details from Marcel Duchamp's *The Large Glass* (1915–1923), it is a merger of painting with performance, movement, sculpture, and sound, and contains an explicit homage to Duchamp, whose ideas about art were crucial to both Johns and Cunningham. This hybrid object made perfect sense for the Walker's collection, which aspires to document the bridging of boundaries between disciplines that artists make regularly but museums rarely are nimble enough to mimic. In addition to acquisitions, the Walker has presented Johns' work in solo exhibitions, most notably *Jasper Johns: Printed Symbols*. That 1990 survey of the graphic oeuvre, organized by curator Elizabeth Armstrong, drew on the print archive acquired the year before.

Since that survey ended its long tour, close to fifty new prints have been added to the archive. The current exhibition, *Past Things and Present: Jasper Johns since 1983*, was conceived as a way to present these glorious new images to our audiences as well as a chance to update the 1990 exhibition and produce new scholarship on the collection. But more than that, a look at the past two decades of Johns' thinking will allow a focused study of work that is markedly different, in some ways, from the iconic flags, targets, and crosshatched abstractions of the 1950s through 1970s. I am extremely grateful to Joan Rothfuss, curator of the permanent collection, who both suggested this undertaking and worked with the artist in realizing it according to their shared standards of excellence. Joan's interest in Fluxus and Dada coupled with her faith in painting's continued ability to surprise made her an exceptionally good partner for Johns. Her patient, quiet approach to appreciating art reveals a deep personal commitment and intelligence, which is amplified by a wonderful sense of play that allows meaning to percolate up from the artist's own work.

This project would not have been possible without support of many kinds from many quarters. First, we must thank Judy Dayton and her late husband, Kenneth, whose support of the Walker and of Johns have come together once more to make marvelous things happen. Additional assistance has come from Martha and Bruce Atwater, Margaret and Angus Wurtele, The Broad

1 Quoted in Coosje van Bruggen, *Bruce Nauman* (New York: Rizzoli, 1988), 23.

Art Foundation, and the Fifth Floor Foundation. We extend our gratitude to all those collectors—private and institutional alike—who have lent cherished objects to this exhibition. We knew borrowing works by Johns would be challenging, but these collectors understood the joy such loans could bring to a wide public; I thank them, then, for being brilliant Johns advocates as well as good citizens. Finally, thanks to those museums and museum directors who have supported the project by becoming our partners on the exhibition tour: Thomas Styron of the Greenville County Museum of Art, Greenville, South Carolina; Richard Calvocoressi of the Scottish National Gallery of Modern Art, Edinburgh, Scotland; Kosme de Barañano of IVAM Institut Valencià d'Art Modern, Valencià, Spain; and Enrique Juncosa of the Irish Museum of Modern Art, Dublin, Ireland.

Outside our walls, many individuals helped with the organization of this project. First, the staff at Johns' studio—led by Sarah Taggart and also including Lynn Kearcher, John Lund, and James Meyer—were infinitely helpful whenever we needed information, photographs, appointments, phone numbers, ideas, and other assistance. Gallerists Barbara Castelli, Margo Leavin, and Bob Monk assisted with loans, and Bill Goldston, director of Universal Limited Art Editions and Johns' longtime printmaking collaborator, coordinated production of the beautiful poster the artist conceived especially for the exhibition. Art historians Richard Shiff and Victor Stoichita (and his translator, Anne-Marie Glasheen) helped make this catalogue a tantalizing addition to the Johns literature.

Closer to home, Joan was assisted by curatorial interns Alisa Eimen and Sara Marion, who provided able research help; administrative assistant Lynn Dierks, who managed the details of the project and also served as director of the exhibition tour; registrar Elizabeth Peck; and installation crew chief Jon Voils. The design and editorial team for this beautiful volume was design director Andrew Blauvelt and graphic designer Alex DeArmond, editors Kathleen McLean and Pamela Johnson, and publications manager Lisa Middag. All of them are due enormous credit for their inspired and assiduous work. I also thank all the members of the Walker's Board of Directors, who provide such important support for our programs.

Finally I must thank Jasper Johns. His contributions to this project have been gracious and plentiful: he has lent numerous works from his own collection; hosted several conversations with and visits from Walker staff, one of which found me seated at his dining table, enjoying a delicious lunch he cooked using ingredients fresh from his garden; created a poster to celebrate the project; and provided insights and feedback when asked. His sympathetic rearrangement of Joan's original exhibition title—*Things Past, and Present*—suggests a profound and unsentimental clarity of thought that requires no punctuation. His work, of course, is the most inexhaustible and generous gift we all can share.

Kathy Halbreich
Director, Walker Art Center

Introduction

Reflecting on Jasper Johns' work on the occasion of his 1996 retrospective at the Museum of Modern Art, New York, scholar Rosalind Krauss referred to his career as "riven." She is not alone in remarking on the change in his approach — evident beginning in the early 1980s — toward a more openly autobiographical and personally expressive iconography. Johns himself acknowledged the shift in a 1984 interview when he admitted that "in my early work I tried to hide my personality, my psychological state, my emotions. . . . but eventually it seemed like a losing battle. Finally, one must simply drop the reserve. I think some of the changes in my work relate to that."[1] Several recent exhibitions and essays have delved into the work of this period, and *Past Things and Present* continues this study.[2] While the exhibition and catalogue focus on the new motifs and strategies in Johns' work, they also recognize that the notion of disjunction depends on an assumption about the connectedness of those things that have been separated. Johns, of course, has always signaled his interest in dual situations and apparent contradictions. In this project, we follow his lead.

The exhibition is organized around major motifs that Johns has introduced since 1983, beginning with the important canvas of that year, *Ventriloquist*. Its title suggests a secondary or "other" voice and a lateral shift or movement to the side — a disjunction that manages not to sever the cord of connection. One of several images of the early 1980s that "takes place" inside the bathroom of the artist's former home in Stony Point, New York, this picture (like ventriloquism itself) operates through both illusion and obvious artifice. Recognizable objects from Johns' studio and home float impossibly in a shallow pictorial space that conflates bathroom wall, picture plane, studio wall, and even the inside of one's eyelids. Several writers have noted that Johns had seen at this time a work by Frida Kahlo, *What the Water Gave Me* (1938), which depicts her in a bathtub gazing at scenes from her life that float on the water's surface.

Johns continued to develop the bath pictures during the late 1980s, adding many new motifs including, notably, several distorted, fragmented, or ambiguous female faces drawn on trompe l'oeil cloths or sheets of paper. One might reasonably link such canvases to the bathers of Paul Cézanne, Edgar Degas, and others, but perhaps the more telling comparison is to Marcel Duchamp's final work, *Manual of Instructions for Marcel Duchamp Étant donnés: 1° La Chute d'eau 2° Le Gaz d'éclairage* (*Given: 1. The Waterfall, 2. The Illuminating Glass*) (1946–1966). In this construction, the viewer looks through a peephole in a wooden door at an oddly splayed nude female figure with a trickling waterfall in the landscape behind her. In Johns' bath pictures, the viewer peeks in from behind to find the artist/bather in a small private space where he (and we) contemplate a wall, a wooden door, and a procession of images that allude to the artist's life and work. Nakedness is implied, and water is always flowing from the tub's spigot — a punning visual reference to male "plumbing." Johns has reversed the sexual and gender codes followed by both Cézanne and Duchamp, and created images in which voyeurism is replaced by a sense of quiet isolation within one's own psyche.

In *The Seasons* series, which comprises dozens of paintings, drawings, and prints, in which the artist addresses a time-honored theme: the cycle of human life, death, and rebirth. Growing from a quartet of paintings done in 1985 and 1986, the series has been a rich source of imagery, one Johns has returned to as recently as 2000. The complex iconography of these works, which has been examined by numerous scholars, including Roberta Bernstein, Judith Goldman, and Barbara Bertozzi, is anchored by a shadow portrait of the artist that is cast on renderings of the floors — tile, brick, and wood — of various residences he has had. Despite the visual pun on the figure-ground relationship, the picture space in these works is no less shallow than in *Ventriloquist* and the bath works, and presents a narrative about Johns' own career that is set against the changes of the seasonal cycle.

1 From an interview with April Bernard and Mimi Thompson, "Johns on...", *Vanity Fair* 47, no. 2 (February 1984), 65. Reprinted in Kirk Varnedoe, ed., *Jasper Johns: Writings, Sketchbook Notes, Interviews* (New York: Museum of Modern Art, 1996), 214–217.

2 Essayists on this topic include Gary Garrels, Jill Johnston, Robert Rosenblum, Mark Rosenthal, John Yau, and others. See selected bibliography on page 149 for details.

The quotation or appropriation of motifs — as opposed to their invention — is a strategy Johns has long used, in part to help him hide his "personality, psychological state, and emotions" by removing his imagination from the artistic equation. During the 1980s and 1990s he expanded on this practice by incorporating tracings of works by Matthias Grünewald, Hans Holbein, and others in his paintings, drawings, and prints, often as the main motif. This variation on the student practice of making copies "after the masters" has offered Johns the chance to explore what happens when a highly expressive figurative image is emptied of its content and its "shell" is reused as an image on its own. Does other content move in to fill it? Or does the shell itself somehow steer the viewer toward the original content? One of these tracings is Johns' infamous Green Angel, whose source — kept secret by the artist — has been the focus of much scholarly speculation. More recently he has begun using the traced outlines of a fragmented canvas by Édouard Manet that was reconfigured by Edgar Degas — a quotation that also highlights the respectful recuperation of an artist's work by one of his peers.

The artist's studio has been a rich theme historically — think of Diego Velázquez, Jan Vermeer, Pablo Picasso, Henri Matisse — and an area of interest for Johns since the beginning of his career, when he made Canvas (1956). A rectangle of stretcher bars attached to the front of a canvas, all painted in monochromatic gray encaustic, the work suggests a small painting that has been turned face down atop a larger one. The arrangement is a melancholy one, evoking refusal, reversal, absence, silence. In the 1980s and 1990s he has approached the studio theme often — in Ventriloquist and related works, and most recently in images that feature a flat plane (the studio wall) against which a reclining plane (the turned canvas) seems to lean. Densely layered with disparate allusions to his past and present, these pictures suggest scrapbooks as well as studio walls. In them, Johns explores the interplay of pictures and memories.

In 1997 Johns began a new body of work, now known as the Catenary series, which is named for its principal motif — an engineering term denoting the curve formed by a flexible cord that hangs freely from two fixed points. The paintings, drawings, and prints in this series include both real and painted catenaries that somehow span the image; one or both ends are usually fixed to a slat of wood at the edge of the work (this might be painted or drawn, too). Some include patterns (harlequin diamonds, embroidered Chinese silk) that directly allude to Halloween costumes the artist wore as a child. With their muted palettes and spare imagery, the works recall his monochromatic gray canvases of the 1960s. Like those earlier paintings, these new works imply the presence of the figure: costumes are worn, and bridges facilitate the passage of the body from one zone to another. The human presence has always inhabited Johns' work; it is simply more or less evident beneath his expressively worked surfaces.

With this exhibition and catalogue, we are delighted to offer the chance for continued study of Johns' recent work. There is much more looking to be done.

Joan Rothfuss
Exhibition Curator

Preference without a Cause
Richard Shiff

I wouldn't exaggerate the idea of choice.
I'm not sure what's chosen. It's what I did;
it's what I've done. I've moved in that way.
I don't know if it's out of choice or out of
necessity—how my mind *must* move.
—Jasper Johns, 1980[1]

The distinction I try to make between
necessity and subjective preference seems
unintelligible to Johns. I asked him about
the type of numbers and letters he uses—
coarse, standardized, unartistic[:] "Do you
use these letter types because you like them
or because that's how the stencils come?"
"But that's what I like about them, that they
come that way."
—Leo Steinberg and Jasper Johns, 1962[2]

When art historian Leo Steinberg puzzled through the early art of Jasper Johns in 1962, he kept an open mind and let his analytical insecurities show. Johns appreciated Steinberg's self-effacing stance: "He saw the work as something new, and then tried to change himself in relation to it, which is very hard to do. I admired him for that."[3] Steinberg later recalled that he had cast himself in the dialogue "as a slightly bewildered stooge."[4] The conceit illuminated the peculiarity of Johns' creative decisions. Here was an artist who chose a form because he felt he liked it—nothing odd there—yet the chosen form was the only one of its type available. This doesn't amount to much of an active preference, as Johns intimated in a later interview: "I wouldn't exaggerate the idea of choice."

Yet Johns' effects shouldn't be regarded as simply accidental, for the typical consequences of his non-choices are familiar to him. We surmise, then, that he intends his effects at least with respect to their general appearance; or, if not, he might as well intend them because he knows from experience how they will appear. How much, in fact, does he know? Interpreters lack an answer because Johns leaves them unable to attribute unambiguous motivation to the character of his works. With causal histories rendered inconclusive, an interpreter is forced to ponder the work instead of assuming that all explanation must revert to the known or emerging character of the artist. Perhaps *this* is what Johns intends—to deflect us from the artist and keep us involved with the work, on the model of his own involvement.[5]

Witness the account he offers of one of his techniques: "I will sometimes apply ink on a sheet of plastic and let it dry. I put it there and it does something. . . . Some people would see that as chance, but I would see it simply as a way of working."[6] As a type, Johns' ink-on-plastic drawings have a distinctive look with strangely irregular contours—a factor of the flow, evaporation, and surface tension of the liquid ink. Clearly, he likes the type; otherwise he wouldn't be involved with it. *Tracing* (1989; cat. no. 27; p. 79) combines two given elements: the configuration established by a Hans Holbein portrait, which he has traced; and the character that ink on plastic assumes—the ink's character, not Johns'. Holbein's figure comes the way it is; ink comes the way it is. Their combination, which the artist has brought about, is novel. Johns seems to describe such work as he describes himself, rendering agency open-ended, ambivalent, sometimes even indifferent, but never denied. His ink-on-plastic process "does something"; and his choice of tracing a configuration through this process, accepting the result, is, he admits, "what I did."

However we might define this attitude, Johns applies it not only to material things like runny ink but also to the course of his running thoughts: "[A painter] just paints paintings without a conscious reason. . . . Your thought takes a certain form and you have to follow it."[7] To follow a thought—the way it moves—is absorbing. Things, thoughts, and thoughts about things become objects of investigation through Johns' artistic actions, the choices or non-choices for which the cannily "bewildered" Steinberg sought a causal pattern or strategy. It may have been bemused wonder, which Johns applies to the most familiar objects and operations. In

1 Jasper Johns, interview by Roberta Bernstein, January 18, 1980, in Kirk Varnedoe, ed., *Jasper Johns: Writings, Sketchbook Notes, Interviews* (New York: Museum of Modern Art, 1996), 201 (original emphasis). Statements quoted from this book, hereafter cited as *Writings*, will be identified by date of publication, if no more precise date can be given.

2 Conversation between Leo Steinberg and Jasper Johns, reconstructed by Steinberg and approved by Johns, published May 1962, *Writings*, 83–84.

3 Johns, statement to April Bernard and Mimi Thompson, published February 1984, *Writings*, 216.

4 Steinberg, statement of December 13, 1992, *Writings*, 84. Steinberg's critical essay performed all too well, with many subsequent writers quoting the fictive dialogue as if it had been spoken verbatim (Steinberg, statement to author, March 17, 2003).

5 One of the aims of an artist or of anyone, Johns says, is to do "something a little more worthwhile than oneself" (Johns, interview by Richard Field, April 23, 1999, audiotape transcript, unpublished [courtesy Jasper Johns and Richard Field]).

6 Johns, interview by Bryan Robertson and Tim Marlow, published winter 1993, *Writings*, 287.

7 Johns, statement to *Newsweek*, published March 31, 1958, *Writings*, 81; interview by Amei Wallach, February 22, 1991, *Writings*, 261.

1990, when asked about the fact that he had just restored one of his early Map paintings, Johns recalled his thinking: "I was doing the restoration, and I said—just casually—that it would be easier to repaint this than to restore it . . . and I wondered, Well, would it be?" Hence, a completely new work to substitute for the old: "I was simply replying to my idea that it would be easier, and wondering whether it would."[8]

Johns keeps his sequence of thoughts moving. Movement doesn't solve a problem but introduces new dimensions to possible problems. He runs his thinking through an operation, observing the outcome as he produces it, thinking as if thoughts were malleable. Any distinction between painting and thinking becomes vague, like the difference between allowing something to happen and causing something to happen. His paint is neither a translation, nor an expression, nor a representation of his thought but something closer to its own content—a fact. "You may be making a mark and thinking of a ribbon or a tree," he tells Richard Field. "It is a fact but not a representation."[9] The linkage between thinking and painting is immediate and unique (a "fact") rather than conventional and repeatable (as in "representation" or the use of signs in general). Like his stenciled letters, Johns' thoughts "come that way"—seemingly already in the specific form of paint.

Racing Thoughts

Many things, wherever one is, whatever one's doing, happen at once. People are polyattentive.
—John Cage, 1964[10]

In seeing one thing we probably see many.
—Jasper Johns, 1992[11]

One of Johns' most quoted instructions to himself states: "Take an object, do something to it, do something else to it."[12] The initial object isn't sought (chosen) but taken, having absorbed a moment's focused attention. Yet it is something given to attention by the chance circumstance of its availability. Johns doesn't conceive of art as chance, but process.[13] He has often mulled over the puzzling difference between active cause and passive effect, active and passive attention, taking a direction and being given one, expressing desire and acquiring desire: "What you do alters what you want to do."[14] One of his notes juxtaposes "I take it to mean" with "I use it to mean."[15] In this instance, "taking" is the more passive term, suggesting that the meaning has been given by someone else; yet taking is putting to use for oneself. Another of the artist's notes, punning, defines "occupation" as "tak[ing] up the space 'with what you do.'"[16] This makes occupation active and passive at once: your activity, your occupation, occupies you and leaves no room for anything else.

8 Johns, interview by Paul Taylor, published July 1990, *Writings*, 249.

9 Johns, interview by Richard Field, unpublished.

10 John Cage, "How to Pass, Kick, Fall, and Run" (1958–1965), *A Year from Monday* (Middletown: Wesleyan University Press, 1967), 133.

11 Johns, interview by Mark Rosenthal, September 2, 1992, *Writings*, 284.

12 Johns, sketchbook note, circa 1963–1964, *Writings*, 54.

13 Not only do Johns' individual works participate in a process, but so does the entire evolutionary course of his production. Asked whether his career had "worked out" for him in a "satisfying" way, he replied with a pun: "It hasn't worked out at all. It's still in process." (Johns, interview by Barbaralee Diamonstein-Spielvogel, published 1994, *Writings*, 299).

14 Johns, interview by W. J. Weatherby, published November 29, 1990, *Writings*, 257. On active and passive attention, compare Johns' interest in some thoughts of Ludwig Wittgenstein, as discussed in Roberta Bernstein, *Jasper Johns' Paintings and Sculptures 1954–1974: "The Changing Focus of the Eye"* (Ann Arbor: UMI Research Press, 1985), 92–93.

15 Johns, sketchbook note, circa 1963, *Writings*, 51. Compare his remarks on tracing an image so that he would feel he "had it right," that it would be "taken" and "not mine" (Johns, interview by Edmund White, published October 1977, *Writings*, 154).

16 Johns, sketchbook note, 1964, *Writings*, 55.

fig. 1

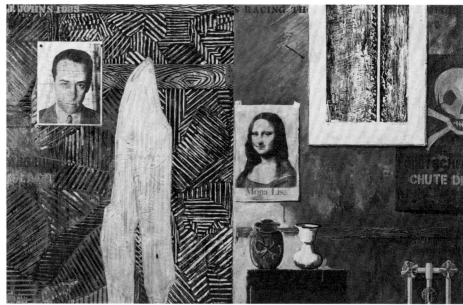

fig. 1 Jasper Johns, *Racing Thoughts*, 1983, encaustic, collage on canvas, 48 x 75⅛ in. (121.9 x 190.8 cm), Collection Whitney Museum of American Art, New York; Purchase, with funds from the Burroughs Wellcome Purchase Fund; Leo Castelli; the Wilfred P. and Rose J. Cohen Purchase Fund; the Julia B. Engel Purchase Fund; the Equitable Life Assurance Society of the United States Purchase Fund; The Sondra and Charles Gilman, Jr. Foundation, Inc.; S. Sidney Kahn; The Lauder Foundation; Leonard and Evelyn Lauder Fund; the Sara Roby Foundation; and the Painting and Sculpture Committee

To Johns' practice of taking what is given, art historians are likely to relate the "readymades" that Marcel Duchamp appropriated and then reoriented, altered, or otherwise "assisted."[17] Johns enjoyed a casual acquaintance with Duchamp but was more closely associated with someone who in many ways makes a better figure for comparison: John Cage. "I felt that I was learning something, usually, when I was around John."[18] With his belief that "people are poly-attentive," Cage encouraged taking ambient sounds and unpredictable auditory events (the given) into his live musical performance. "These pieces," he said of a series of his performances during the 1950s, "are not objects, but processes, essentially purposeless." Unaware of an overriding aim, you become all the more attentive to detail. Immediately after one of Cage's college engagements, a student reported that "something marvelous had happened[:] 'One of the music majors is thinking for the first time in her life.'" Another student, equally excited, asked her professor simply to "listen."[19] The two students had been moved in different ways: one was inspired to think, the other to listen. But they had also been moved in the same way, because thinking and listening had become one process, like Johns' thinking and painting. Neither element could be determined as the cause or effect of the other.

Sometimes we try to listen to our thinking, as if we were able to pause and take hold of our thoughts, manipulating them like external objects.[20] But thoughts can also be intrusive, especially when they run or race ahead of our listening and comprehension. We may feel as if we no longer actively control them; instead, we have too many and are reduced to suffering them.

17 On Duchampian motifs and operations in Johns' work, see Roberta Bernstein, "'Seeing a Thing Can Sometimes Trigger the Mind to Make Another Thing,'" in Kirk Varnedoe, *Jasper Johns: A Retrospective*, exh. cat. (New York: Museum of Modern Art, 1996), 43–46 (hereafter cited as *Retrospective*).

18 Johns, interview by Billy Klüver and Julie Martin, February 26, 1991, *Writings*, 270. See also Johns, interview by Ruth Fine and Nan Rosenthal, June 22, 1989, in Nan Rosenthal et al., *The Drawings of Jasper Johns*, exh. cat. (Washington, D.C.: National Gallery of Art, and New York: Thames and Hudson, 1990), 83 (hereafter cited as *Drawings*); John Cage, "Jasper Johns: Stories and Ideas" (1964), *A Year from Monday*, 73–84.

19 Cage, *A Year from Monday*, 134–135.

20 Compare Johns' statement: "Sometimes [the] only way you can think to proceed is through repetition of something which gives you a sense that you are doing what you do, thinking the thoughts you have" (Johns, interview by Richard Field, unpublished).

Polyattentiveness may not be enough to keep the situation pleasurably interesting. The term *racing thoughts* refers to a psychological condition that often accompanies anxiety; in its most extreme manifestations, it indicates a serious manic disorder and borders on the so-called loose association that characterizes schizophrenia.[21] A person's mind "races" uncontrollably from one thought or topic to another, usually with some kind of logical connection, but too quickly for any link to be put to practical use. The experience is unsettling, and to outside observers the pattern of thought, the form of its expression, may seem incoherent. Perhaps Johns would nevertheless accept the form, observing it while maintaining his equanimity and curiosity. It would be another case of "how my mind must move."

In 1983 Johns titled a bipartite composition using a stenciled inscription at the top of one side: RACING THOUGHTS (fig. 1).[22] (He split the inscription to suggest cylindrical rotation, to be discussed below.) Around this time or shortly before, the artist suffered a mild form of racing thoughts and also became acquainted with the name of the condition. He was amused to learn that it existed as a general syndrome, beyond his specific bout with it.[23] Because he tends to conflate personal preference and material necessity, active and passive causes, it would be un-Johnsian to assert a causal link from the biographical fact of his anxiety to his title *Racing Thoughts*, or still further to the thematic content of his image. This would mistake a "fact," a coincidental conjunction, for a "representation," a kind of rule. The associations should remain loose—not in the pathological sense (schizophrenia) but merely in a logical sense. Johns' title is itself a kind of racing thought, a stimulus to the continuing movement of an attentive mind.

Racing Thoughts depicts a number of objects and pieces of art, all of which were familiar occupants of the artist's studio and domestic environment in one form or another (for instance, the avalanche warning sign existed as a reproduction from a Swiss newspaper).[24] Stenciled like a sign, the title of the painting refers to an independent topic of Johns' interest. The stenciling itself forms a visual object in the total array, which has no obvious thematic order. "They must be things I was thinking of," he has commented, tautologically.[25]

Johns' episode of racing thoughts (of the pathological sort) was brought on by temporary anxiety and interfered with his sleep. Whatever experience he had in the studio while painting was, presumably, distinct from his malaise and free of that anxiety. Yet his description of his condition refers not only to verbalization but also to visual thinking: "Images, bits of images, and bits of thought would run through my head without any connectedness that I could see."[26] The various identifiable elements in his painting—a jigsaw puzzle portrait of Leo Castelli, a lithograph by Barnett Newman, a pot by George Ohr, and other items—link up only through their loose association with the artist's daily environment. Within the array, however, any particular detail is likely to bear an on-the-spot connectedness to any other detail. The visual logic is sometimes formal and perceptual, sometimes conceptual and metaphoric. On the formal side, diagonal striations to the left of the Newman lithograph (counterbalanced by the illusionistic

21 Robert Berkow, ed., *The Merck Manual of Diagnosis and Therapy* (Rahway, New Jersey: Merck Research Laboratories, 1992), 1599; Irving I. Gottesman, *Schizophrenia Genesis: The Origins of Madness* (New York: Freeman, 1991), 14–15.

22 The painting is in encaustic. A second painting with the same title was completed in 1984, in oil.

23 Johns, statement in *Jasper Johns: Ideas in Paint*, television documentary (directed by Rick Tejada-Flores, produced by WHYY Philadelphia, 1989), in *Writings*, 224.

24 Nan Rosenthal, "Drawing as Rereading," in *Drawings*, 33, 45, n. 28.

25 Johns, interview by Demosthène Davvetas, published April 1984, *Writings*, 218.

26 Johns, statement in *Jasper Johns: Ideas in Paint* (1989), *Writings*, 224.

fig. 2

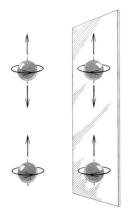

fig. 3

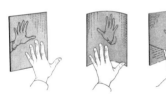

fig. 2 Illustration by James Egleson from *Scientific American* article, "The Overthrow of Parity," by Philip Morrison, vol. 196, April 1957: 47

fig. 3 Illustration by Irving Geis from *Scientific American* article, "Mathematical Games," by Martin Gardner, vol. 198, March 1958: 128

shadow of a nail) echo its interior markings as Johns rendered it. On the metaphoric side, a prominent cluster of encaustic drippings runs downward just above the bathtub fixtures in the lower right corner, enforcing the association with water. The cloverlike motif on the George Ohr pot (bottom, right of center) is analogous to the structure of the bathtub knobs. This is part formal, part metaphoric: two instances of rounded crosses that evoke turning; two vessels that might contain water, the pot and the implied tub.[27] A viewer's verbalized thoughts race from one visual detail to the next.

The Overthrow of Parity

One of Johns' sketchbook pages, dated circa 1960, includes the following notations, which seem to refer to two different types of mirrors:

> Can a rubber face be stretched in such a way that some mirror will reorganize it into normal proportion?
> Find Scientific American with information dealing with mirror that will reverse normal (mirror) image
> The overthrow of parity[28]

Among a number of possibilities, these jottings clearly relate to an article published in the April 1957 issue of *Scientific American* titled "The Overthrow of Parity."[29] One of its illustrations shows a rotating ball that could be confused with its mirror image because it has up-down as well as left-right symmetry in relation to its spin (top, fig. 2). A similar ball, but with a "preferred direction" in relation to its spin, becomes fundamentally different from its reflection (bottom, fig. 2).[30] This intriguing diagram may bear on Johns' conception of the second of his two mirrors, the one that "reverses"; but it pertains to a physicist's laboratory much more than to an artist's studio. More likely, he was trying to locate or recall an account of a less rarefied kind of mirroring that followed in *Scientific American* one year later (fig. 3). That article begins with a reference to "left-and-right 'handedness'" as discussed in "The Overthrow of Parity."[31] I have no direct evidence that the artist actually consulted either of the two illustrations; he may never have found the "information" that his note indicates he was seeking.[32] Notions of "handedness" and parity (its lack) nevertheless help to articulate effects in Johns' work that remain remarkably hard to describe. Language keeps failing what the eye senses in this art, so any promising aid to interpretation is worth pursuing.

The first mirror that Johns imagined, the one that would "reorganize" a rubber face, could be used to convert a stretched, twisted, flattened, or otherwise distorted object into a conventionally "normal" image.[33] It seems that the second mirror might be used to do the opposite, to "reverse normal image." "Reverse normal image" is how Johns first wrote the phrase on his sketchbook

27 Johns made this association more explicit in a work on paper, *Study for Racing Thoughts*, 1983 (reproduced in *Drawings*, 291). Asked about the "composition" of his "bathtub" paintings, he referred only to the most fundamental considerations: "I think about how to divide the space of the support and how to introduce the objects that need to be shown. [The paintings] are not very tricky—quite straightforward." (Johns, interview by Ruth Fine and Nan Rosenthal, June 22, 1989, in *Drawings*, 82).

28 Johns, sketchbook note, circa 1960, *Writings*, 50.

29 Philip Morrison, "The Overthrow of Parity," *Scientific American* 196 (April 1957): 45–53. The sketchbook page with the notation "The overthrow of parity" also includes the notations "IN-OUT" and "Anti-matter." The former is an instance of the type of fundamental opposition Johns questioned in his art. The latter may refer to a related article (Geoffrey Burbidge and Fred Hoyle, "Anti-Matter," *Scientific American* 198 [April 1958]: 34–39). A subsequent piece, which used "The Overthrow of Parity" as one of its subheadings, continued the discussion of both parity and antimatter (S. B. Treiman, "The Weak Interactions," *Scientific American* 200 [March 1959]: 72–80, 82–84). Coincidentally, this follow-up account appeared in the same issue as the second of two articles by Bruno Bettelheim. Johns has made direct use of the first of Bettelheim's articles, and Richard Field notes some possible relevance in the second: Bruno Bettelheim, "Schizophrenic Art: A Case Study," *Scientific American* 186 (April 1952): 30–34; Bruno Bettelheim, "Joey: A 'Mechanical Boy,'" *Scientific American* 200 (March 1959): 116–120, 122, 124, 126–127; Richard S. Field, "Chains of Meaning: Jasper Johns' Bridge Paintings," in Gary Garrels, ed., *Jasper Johns: New Paintings and Works on Paper* (San Francisco: San Francisco Museum of Modern Art, 1999), 33–34.

30 My description simplifies the import of the illustration, eliminating reference to emitted particles.

31 Martin Gardner, "Mathematical Games," *Scientific American* 198 (March 1958): 128. The article refers to antimatter, galaxies, and musical composition.

32 Johns' concern for or familiarity with the issue of parity around 1960 appears to have been fleeting. Since 1969 Richard Field has conversed frequently with the artist about his work; he recalls no instance of him referring to parity (statement to author, March 25, 2003).

page; he then inserted the crucial word "mirror" with an arrow. This is why I quoted his notation with the addition of a parenthesis: "reverse normal (mirror) image." Any standard mirror reverses or "mirrors" objects by turning right into left, left into right. But reversing the mirror image is different from reversing the appearance of the object. It amounts to a reversal of what usually appears reversed. This is an operation that two of the three mirrors in figure 3 accomplish; both concave and right-angled mirrors present an image of a left hand that looks like another left hand, not like a right hand. There remains something to consider: Johns' curiosity may have been piqued by the possibility of reversal of a more radical kind. If he noticed the mirroring illustrated in figure 2, he would have been confronted with the strange situation that a number of articles in *Scientific American*, including "The Overthrow of Parity," were attempting to explain.

To what phenomenon does the "overthrow of parity" refer, and why would it have interested Johns (at least to the point that he noted the relevant title or concept)? According to the principle of parity, any fundamental particle of matter should prove to be physically indiscernible from its mirror image; that is, no feature of the reversed image should prevent it from being mistaken for the real thing viewed from some other perspective. If a "normal" particle moves to the left, it will look very much the same if it moves to the right (as, statistically, it should have every chance of doing). A sphere and its mirror image exemplify the usual situation. It makes little sense to distinguish the left side of the sphere from the right or the top from the bottom by labeling opposite ends as if they were fixed poles. Imagine rotating the sphere seen reversed in the mirror: it then assumes the features of the "real" sphere with its fundamental structure unchanged. In the wake of laboratory experiments conducted in 1956, physicists concluded that the behavior of certain short-lived subatomic particles failed to exhibit this expected mirror equivalence or parity. There was a left-handed world for which a right-handed analogue was nowhere to be seen.

Further description of the situation becomes ever more metaphorical, because the particles in question lack the concrete stability we experience in a billiard ball or any other familiar object. Their "shape" and "position" can be described mathematically, but such features are resistant to direct observation and to denotation in familiar graphic systems. Metaphorically, what the 1956 experiments established was this: the mirror-image reversal of certain subatomic particles is a reversal that can't be reversed. To put it the other way around, the particle's mirror image no longer corresponds to some conceivably real, physical configuration. It was as if nature had decided to express a preference where there had never been one. In these exceptional instances of the violation of parity, nature established an "intrinsic difference between right and left," which, as opposing orientations, had always been only relative values, never absolute.[34] The "mirroring" of the newly observed particles was strange indeed.

The first mirror that Johns' sketchbook note evoked, suitable for rubber faces, might be used to demonstrate that an object and its "stretched" perspective are ultimately indiscernible and

33 See Richard Shiff, "Anamorphosis: Jasper Johns," in James Cuno, ed., *Foirades/Fizzles: Echo and Allusion in the Art of Jasper Johns* (Los Angeles: Wight Art Gallery, University of California, 1987), 147–166.

34 Treiman, "The Weak Interactions," *Scientific American* 200, 82.

fig. 4

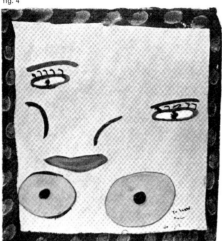

therefore obey the existing law of parity. The normal object and its distorted variant would eventually behave like two different views of a single object, perhaps seen from the right and seen from the left. But when parity comes into question, it is as if we were asking, "When does the reverse of right result in something other than left?" Right-and-left parity would be violated by any situation in which the "handedness" became absolute, where a turn to the left represented something more significant than the mere reversal of a turn to the right. Like Johns, the newly observed subatomic particles seemed to be doing what they "wanted" to do instead of obeying a preordained rule. Why? Because this is what they did. In 1956 particle physicists encountered preference without a cause. They could observe what was happening but couldn't determine its cause through any existing logic or principle. Generalization failed.

To repeat: with parity gone, if you reverse an object in a mirror, you have the appearance of a different object, not merely the same object reversed. Perhaps this is the hidden implication of Johns' note about a "mirror that will reverse normal (mirror) image." It's true that some rather ordinary mirrors do this, although not the standard flat ones (fig. 3). In situations where parity fails, however, no mirror reversal will be "normal." Each will be a novel fact in itself.

Reversal with a Real Difference

Johns seems to prefer artistic operations to which reversal comes naturally: tracing, transferring, imprinting, mirroring. All happen to be aspects of printmaking. Given the agility of his devices for projection and tracing, Johns' use of print mediums need not result in the usual kinds of left-and-right reversals. In this area, surely, he exercises a certain choice—or, perhaps merely a testing of unusual possibilities.[35]

Beginning in works of 1983 (including *Racing Thoughts*), the configuration of a certain "demon" appears frequently. Johns traced this figure from a book of reproductions of Matthias Grünewald's Isenheim Altarpiece.[36] He transforms it not only by varying the medium used to delineate it, but by shifting its orientation. The demon occupying the inset overlayer in the intaglio *Face with Watch* (1996; cat no. 58; p. 109) is flopped, or doubly reflected, in relation to its original compositional order (imagine it rotated three-dimensionally, front to back, or mirrored two-dimensionally, then rotated clockwise on the plane). For the mezzotint *Untitled* (1995; cat. no. 56; p. 107), Johns set the same figure in the "correct" orientation, as if pressed into the lower left corner of the composition, and here occupying an enframing underlayer. In contrast, a face Johns inscribed in the inset overlayer of this print is reversed, left to right, in relation to its source—a drawing by a schizophrenic child (fig. 4) with which psychologist Bruno Bettelheim illustrated a 1952 *Scientific American* article.[37] Although the reversal of the inset image might be associated with the mechanics of printmaking, it can also be imagined as a three-dimensional rotation of the source image, front to back, around a vertical axis.

35 "That the print is the reverse of the image drawn on the stone must impress even novice printmakers. In the shop, one is always conscious of these mirror images, and this awareness has influenced my paintings in which images are sometimes mirrored or deliberately reversed" (Johns, interview by Bryan Robertson and Tim Marlow, published winter 1993, *Writings*, 288). *Hand* (1963), a Johns lithograph, illustrates the kind of reversal associated with parity. It consists of two impressions of a right hand (one in soap, one in oil) reversed in relation to each other (thumb down, thumb up), reversed again by the indexical imprinting, and yet again by being lifted from the lithographic stone. Remove any one reversal and a left hand appears. Such pictorial issues seem to have concerned the artist from the start. With regard to *Untitled* (*Green Painting*) 1953, Menil Collection, Houston), he comments: "The idea was to make something symmetrical that didn't appear to be symmetrical" (Johns, interview by Michael Crichton, late 1991 or early 1992, in Michael Crichton, *Jasper Johns* [New York: Harry N. Abrams, 1994], 76 [n. 1]). The work in question is a painted collage consisting of squares of paper arranged in a grid, each of which Johns had folded into quarters and torn, then unfolded to create a symmetrical microcosm. These elements, linear combinations of them, and the grid itself are consistent with principles of symmetry, yet no encompassing symmetrical order can be discerned.

36 See Bernstein, "'Seeing a Thing,'" *Retrospective*, 52–54, 85.

37 Bettelheim, "Schizophrenic Art: A Case Study," 33.

fig. 5

Johns inscribed his name and a date at the base of the mezzotint *Untitled*, interlacing it with the name Bruno Bettelheim, the latter being reversed. I'm tempted to conclude—it's a racing thought—that the association of the Bettelheim name to the Bettelheim image "caused" this reversal. Yet Johns had already made *Untitled* (1991; fig. 5), a painting of nearly the same configuration with the same interlaced inscriptions, where the name Bettelheim is reversed but not the Bettelheim drawing. The interlacing itself is possible only because the name Jasper Johns, when a four-digit date is appended, and the name Bruno Bettelheim each contain a total of fifteen characters—a "comes that way" coincidence of a sort Johns seems to like. Would any of these manipulated reversals and rotations, as well as aligned accidents, result in serious expressive differences between one painting and another? Or is the artist indulging in manipulation for the sake of increasing formal variation in his total output?

I suspect that Johns regards such changes as much more than mere parity-value exchanges (left to right, up to down, over to under, and the like). Shifts in form entail shifts in the psychological dimension—emotional as well as cognitive. Johns' art presents situations where the reverse of left is not right, but left reversed, which may be strangely different not only from left but even from right. The emotional resonance varies accordingly. Asked about his numerous tracings of the same few details from Grünewald's multipaneled narrative in the Isenheim Altarpiece, Johns replied:

> I was attracted to the qualities conveyed by the delineation of the forms and I wanted to see if this might be freed from the narrative. I hoped to bypass the expressiveness of the imagery, yet to retain the expressiveness of the structure. In some tracings, this seemed to happen, but not in others.[38]

The implication of Johns' final sentence is unclear. I assume that among the results of his process he had observed this one: in certain tracings the expressiveness of the fundamental structure was unchanged, whether or not still linked to the narrative; whereas in other tracings, unpredictably, a new expressiveness appeared.

If expression is in the structure, then every reorientation of the delineated pattern brings with it the potential for a new expressiveness, an emotional content independent of the thematic, narrative, and iconographical elements that remain constant. In this respect Johns' art overthrows parity—not subatomic, but pictorial. His reversals of form obliterate neither the original structure nor the original subject matter, yet they may not allow reconversion to or recovery of the original identity, emotion, or effect. The situation relates to a project Johns had imagined around 1960: "Make something, a kind of object, which as it changes . . . offers no clue as to what its state or form or nature was at any previous time."[39] Cage had entertained similar notions during the 1950s, striving to make his music experientially vivid. "Each performance [of a composition] is unique," he said, referring to his threefold repetition of a set of five

fig. 5 Jasper Johns, *Untitled*, 1991, oil on canvas, 60 x 40 in. (152.4 x 101.6 cm), Collection the artist

38 Johns, interview by Bryan Robertson and Tim Marlow, published winter 1993, *Writings*, 288.

39 Johns, sketchbook note, circa 1960, in *Writings*, 50.

fig. 6

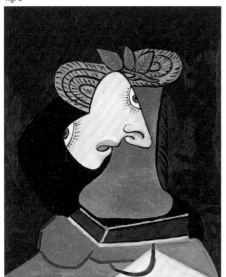

compositions that constituted the totality of one of his musical events. And if the repeated, reoriented sounds didn't acquire a novel identity, if they "weren't just sounds," Cage wryly explained to his listeners, then he "would do something about it in the next composition."[40] He would ensure that his music expressed its unrepeatable particularity.

Sometimes reversals, reorientations, and repetitions just seem . . . different. Who can say why? "How does one see that one thing is not another thing?" Johns asked himself around 1967. "Something can be either one thing or another (without turning the rabbit on its side)."[41] Here Johns is likely to have been thinking of Ludwig Wittgenstein's discussion of a famous picture-puzzle of a "duck-rabbit," an image that appears frequently in Johns' later art.[42] His lithograph *Untitled* (1990; cat. no. 32; p. 86) uses the contradictory duck-rabbit as its inset overlayer while a tracing of the Grünewald demon appears as its enframing underlayer. Johns rotated the demon halfway around the picture surface from its "normal" position, reversing up and down as well as left and right. It is Grünewald's demon, but no longer Grünewald's demon. Likewise, and more obviously, the duck-rabbit is one moment a duck, one moment a rabbit. When you project the rabbit from (so to speak) its other side, you don't see a rabbit in reverse but something different, a duck. Seeing a duck doesn't mean that you prefer ducks to rabbits. Johns understands, as Wittgenstein did, that these logical and psychological confusions derive from our perception of structured pictures, not from seeing the things they represent: "A rabbit (a real rabbit) on its side is not a duck," Johns assures himself.[43] Yet, when parity is overthrown, a rabbit on its side might as well be a duck—at the least, it will no longer be a "rabbit." "Sidedness" will have become absolute, like "handedness." In Johns' art, with or without his use of picture-puzzle imagery, sidedness and handedness become absolute.

Melted Picasso

In 1988 Johns painted two versions of *The Bath*, using a format reminiscent of *Racing Thoughts*. He derived part of this complex configuration from an image he had noticed reproduced in a book and had introduced to his art in 1986—Pablo Picasso's *Woman with Straw Hat* (1936; fig. 6).[44] Johns "has always been involved with Picasso more than with any other painter," Leo Castelli, a longtime observer, testified in 1996.[45] In *The Bath*, Picasso shares the pictorial stage with Grünewald, whose demon appears sideways in the underlayer or "background" of both versions. As always (but with slight variations), Johns' tracing retains the unusual perspective Grünewald gave his figure, with the position of its thrown-back head sending nose, eyes, and mouth toward the periphery of an oddly contoured face viewed from behind and above. In one version of *The Bath* (fig. 7), Johns' placement of the demon's head echoes the Picasso head to its right, which has its own odd perspective. There are surprising affinities between the two forms, and, more remotely, some intriguing links between Grünewald's treatment of the face and images by Picasso that underlie *Woman with Straw Hat*.[46] Did Johns combine his Grünewald

fig. 6 Pablo Picasso, *Woman with Straw Hat*, 1936, oil on canvas, 24 x 20 in. (61 x 50 cm), Collection Musée Picasso, Paris

40 Cage, *A Year from Monday*, 134.

41 Johns, sketchbook note, circa 1967, *Writings*, 62.

42 See Ludwig Wittgenstein, *Philosophical Investigations*, trans. G. E. M. Anscombe (New York: MacMillan, 1968), 194; Bernstein, *Jasper Johns' Paintings and Sculptures 1954–1974*, 92–94. On picture-puzzles, including a wife/mother-in-law image, a version of which Johns often employed along with the duck-rabbit, see Dario Gamboni, *Potential Images: Ambiguity and Indeterminacy in Modern Art* (London: Reaktion Books, 2002), 151–155.

43 Johns, sketchbook note, circa 1967, *Writings*, 62. Compare Wittgenstein, 199: "The *impression* [as opposed to the actual picture] is not simultaneously of a picture-duck and a picture-

rabbit" (original emphasis). See also Johns, interview by Mark Rosenthal, September 2, 1992, *Writings*, 283–284.

44 See Bernstein, "'Seeing a Thing,'" *Retrospective*, 73 (n. 108).

45 Leo Castelli, statement to Edmund White, in Edmund White, "MOMA's Boy," *Vanity Fair*, September 1996, 304.

and his Picasso for this reason? Nothing compels this conclusion, because Johns' interest in Grünewald and his interest in Picasso have independent histories. It might simply be the case that the Grünewald tracing fell into place so as to echo an aspect of the Picasso head. This is the way it happened, once Johns made certain decisions regarding the disposition of his chosen elements—like Cage's having decided to play five compositions, each three times, with his choices ultimately creating sounds that were "just sounds." Yet, in the other version of *The Bath* (fig. 8), where the Grünewald demon-head is obscured by Johns' rendering of a spiral galaxy, the Picasso head appears to have been adjusted sympathetically, its "straw hat" manipulated to resemble a nebulous spiral. Such details ought to show "subjective preference" rather than "necessity" (to use Steinberg's terms).

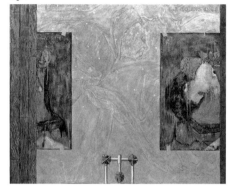

fig. 7

In both versions of *The Bath* Johns' medium is encaustic, a waxy binder kept warm and flowing during application; having cooled and hardened on the canvas, it can be melted as a way of modifying the painting. Like ink on plastic ("I put it there and it does something"), Johns' encaustic on canvas renders the difference between manipulation and non-manipulation indeterminate. Perhaps every feature of *The Bath* is a part of Johns' plan, his "way of working."[47] He altered existing encaustic forms by melting them. Such adjustment, however, entailed allowing the paint to flow; flowing, it created the only form it could assume, given its temperature, viscosity, and the force of gravity. We see the result of Johns' action—part active, part passive—in the Picasso head as it appears in *The Bath*. By affecting the given image so that it no longer mimics Picasso's precise contours, Johns seems to express his personal preference. Yet the immediate cause of the resultant form is a universal law (gravity) rather than an artist's individual desire. Apparent preference and real cause join in no more than loose association. Imagine conversing with Johns on these matters: you might conclude that he made all the sense in the world or no sense at all.

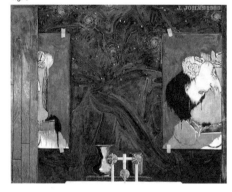

fig. 8

Was Johns asking himself how a Picasso would look if it actually melted? Melting was apparently Picasso's idea to begin with, but probably assumed a more metaphoric form than it did in Johns' application. Johns had enjoyed learning of Picasso's witty response when Picasso first encountered Willem de Kooning's abstractions; he called them "melted Picasso."[48] The description rings true. De Kooning "melted" Picasso-like figures with his fervid gestures. In *The Bath*, it might be argued, Johns accomplished the same by the depersonalized means of heat and gravity. Raising the issue of parity, a Johnsian question would be this: Can a Picasso be melted "in such a way that some mirror will reorganize it into normal proportion?" Answer: probably not, because *Woman with Straw Hat* is already so far removed from natural proportions that it "offers no clue as to what its state or form or nature was at any previous time."

Nothing in either artist's imagery, however strange, would contribute to a physicist's "overthrow of parity." A painter's events are far more pictorial than physical. Yet the works of both confound the "normal" understanding of what pictures do. Pictures by Picasso and Johns mirror, reverse,

fig. 7 Jasper Johns, *The Bath*, 1988, encaustic on canvas, 48¼ x 60¼ in. (122.5 x 153 cm), Öffentliche Kunstsammlung Basel, Kunstmuseum

fig. 8 Jasper Johns, *Untitled*, 1988, encaustic on canvas, 48¼ x 60¼ in. (122.5 x 153 cm), Collection Anne and Joel Ehrenkranz

46 A sheet of Picasso sketches dated the same day as *Woman with Straw Hat* (May 1, 1936) indicates that the peripheral eyes originate in a view of a woman, head thrown back, seemingly asleep in a chair, reclining but not necessarily recumbent (illustration in William Rubin, ed., *Picasso and Portraiture: Representation and Transformation* [New York: Museum of Modern Art, 1996], 72). Picasso had created the same type of thrown-back head, but with eyes obviously closed, in several works of 1927; see illustrations in Christian Zervos, *Pablo Picasso*, 33 vols. (Paris: Cahiers d'Art, 1932–1978), 7:31 (nos. 71, 72), 33 (nos. 78, 79). There are related heads with eyes open: Zervos, 7:30 (no. 68), 31 (nos. 73, 74), 33 (no. 80). Grünewald's demon "reclines" in a manner similar to Picasso's (snoring?) women of 1927 and 1936 but is viewed

from the reverse direction. Johns is unlikely to have known these Picasso figures at the time he painted *The Bath*.

47 Johns, interview by Bryan Robertson and Tim Marlow, published winter 1993, *Writings*, 287.

48 Johns, interview by Amei Wallach, published October 30, 1988, *Writings*, 226. Johns had also heard that Picasso would sit in his bath and, like Johns himself, wonder why he didn't melt.

fig. 9

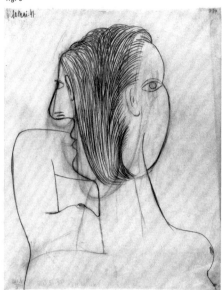

turn, and transform themselves in the most peculiar ways. But not in the same ways. A Johns is no more a rabbit than a Picasso is a duck.

Flat Rotation

> The problem is how to pass, to go around the object and give a plastic expression to the result. [My work] is my struggle to break with the two-dimensional aspect.
> —Pablo Picasso, 1956[49]

Why are Picasso's images still so peculiar, many years after they were created? He wanted to represent bodies with their full volume and, as a painter, to do it flatly. Easy enough to announce, this may not strike us as an unusual undertaking. Yet it is. Conventional painting represents a passage into perspectival space, as does most photography; to the contrary, Picasso's painting passes "around the object," including moving around to its back, rather like sculpture.

Perspectival space is itself what Picasso called "the two-dimensional aspect," the organized visual field he struggled "to break with." He violated perspective in order to "give a plastic expression" to the third dimension, to represent how he sensed the tactile volume. Through sight and touch alike we perceive physical continuity, but in opposing ways. The rounded contours and peripheral features of *Woman with Straw Hat* suggest the volumetric, tactile continuity of the object, not its position in continuous optical space. Conventional perspective and Picasso's flattened rotation are both pictorial projections but competing ones, and one displaces the other.

Passing "around" with his sense of touch, Picasso sometimes represented the front of a figure observed from behind. A drawing of 1941 (fig. 9) indicates hair at the pictorial center of a woman's head, with side-profile and lost-profile views of her face to the left and right respectively. To judge by the position of the figure's raised left arm, she is reclining, resting her head against that same arm. Just as the two sides of her face—anatomically accessible to touch but not to vision—have been rotated around to the front, so her left breast has been rotated from underneath her torso to be revealed as another form in profile along her shoulder. A protrusion at the right of the figure doubles as the second breast and second shoulder. Picasso pictures the figure in its full volume, even though most of its articulated features, occupying its front, would have been unavailable to this view from behind.

With flattened projections of his own, Johns often represents rotation two-dimensionally in the sense of an implied directional movement and three-dimensionally in the sense of the virtual tracing of a volume.[50] Both flat and volumetric in their implications, his pictorial constructions

fig. 9 Pablo Picasso, *Head of a Woman*, 1941, pencil on paper, 10.6 x 8.3 in (27 x 21 cm), Collection Musée Picasso, Paris

49 Pablo Picasso, quoted in Alexander Liberman, "Picasso," *Vogue* 128 (November 1, 1956): 134. For extended analysis of Picasso's "break with the two-dimensional aspect," see Leo Steinberg, "The Algerian Women and Picasso at Large," *Other Criteria*, 125–234; Richard Shiff, "The Young Painter," in Terence Maloon, ed., *Picasso: The Last Decades* (Sydney: Art Gallery of New South Wales, 2002), 25–41.

50 In 1959 Johns stated three "academic ideas" that had held particular "interest" for him. The first was "what a teacher of mine (speaking of Cézanne and cubism) called 'the rotating point of view.'" To this Johns linked Larry Rivers' observation that notable visual events would occur in a picture other than where the eye was focused: "like there's something happening over there, too." Given Rivers' comment, the "rotating point of view" that Johns (and his teacher) associated with Cézanne

and Cubism would have involved shifts of focus to left and right as opposed to full rotation. On the "rotating point of view," see Kirk Varnedoe, "Introduction: A Sense of Life," *Retrospective*, 17; Bernstein, "'Seeing a Thing,'" *Retrospective*, 69 (n. 11). On Rivers' friendship with Johns during the 1950s, see Larry Rivers (with Arnold Weinstein), *What Did I Do?: The Unauthorized Autobiography* (New York: HarperCollins, 1992), 350–351. Rotation was Duchamp's concern as well as Picasso's, but the example of Picasso, rather than a Duchampian precedent, seems to have provided the more immediate stimulus to Johns' work of the 1980s and later. As an example of rotation in Johns at a moment when he may have been thinking primarily of Duchamp, consider the complicated play of the flagstone motif in *Untitled* (1972): Shiff, "Anamorphosis: Jasper Johns," 153–158. Of the three "aca-

demic ideas" that Johns listed in 1959, the second belongs to Duchamp and the third to Leonardo da Vinci, both ready sources of thoughts on mirroring, projection, reversal, and imprinting, which could no doubt be used to extend the line of argument I develop here. On the Leonardo connection, see Bernstein, "'Seeing a Thing . . .,'" *Retrospective*, 67. See also Victor Stoichita's essay in this volume, which discusses the three academic ideas in detail.

fig. 10

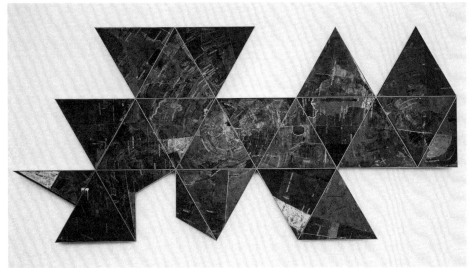

fig. 11

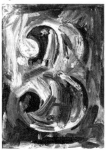 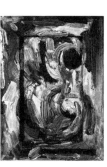

leave viewers with a duck-rabbit choice. We express our preference by seeing Johns' imagery one way or the other. We make a choice without being aware of any compelling cause.

Like his interlaced inscriptions (JASPERJOHNS1991 and MIEHLETTEBONURB), many of Johns' reversals are also potential instances of rotation. In *The Bath*, Johns splits Picasso's "woman with straw hat" in two, with the adjoining edges facing away from each other; this suggests that the image would be restored to its wholeness were it rotated upon a vertical axis, moving around the back before returning to the front. Similarly, a number of flatly patterned paintings and prints have markings along their left and right exterior edges that match up, as if these extremities could be joined; the surface would then have become cylindrical, its flatness rounded (*Cicada* [1979] is one of many examples). Johns achieved the opposite effect with his *Map (Based on Buckminster Fuller's Dymaxion Air Ocean World)* (1967–1971; fig. 10); this work renders the surface of a rotating sphere flat. As if to acknowledge that the parity of a sphere holds even when it appears restructured as an irregularly shaped plane, *Map* can be hung either vertically or horizontally—the choice is arbitrary, another duck-rabbit.[51]

Continuity of front and back engages Johns just as it did Picasso.[52] *Figure 3* (1960; fig. 11) is a double image that covers both recto and verso surfaces of a conventionally stretched canvas. To create the verso image with the same dimensions as the recto, Johns painted it over the stretcher bars as well as the canvas exposed at the back. His two renderings of the numeral, front and back, match up. Because of the match, a viewer can entertain the conceptual illusion that the canvas is uniformly flat and transparent like a pane of glass, despite features that

fig. 10 Jasper Johns, *Map (Based on Buckminster Fuller's Dymaxion Air Ocean World)*, 1967–1971, encaustic, pastel, collage on canvas, 196 ⅛ x 393 1¹⁄₁₆ in. (500 x 1,000 cm), Collection Museum Ludwig, Cologne, Germany

fig. 11 Jasper Johns, *Figure 3* (recto and verso), 1960, oil on canvas, 11 ⅛ x 8 in. (28.25 x 20.3 cm), Collection Yale University Art Gallery, New Haven, Connecticut

51 Having viewed his *Map* displayed at the Montreal World's Fair in 1967, Johns decided, "I didn't like it. It just looked like a map to me . . . [So] I completely repainted it" (Johns, interview by Milton Esterow, published summer 1993, *Writings*, 284). I think Johns meant that his first version of *Map* wasn't convincing as a "painting." It lacked what I have called (with respect to *Racing Thoughts*) an on-the-spot connectedness of the details, which would give the painting a certain coherence—not necessarily logical, but open, loose, and "racing." While Johns was working on *Map*, he was also creating the three panels of *Voice 2* (1968–1971). He hoped they "might be able to accommodate any order or disorder; might be upside-down, sideways, backwards." He was "trying to make the painting have no 'should be,' trying to make it be any way it wanted to

be" (Johns, interview by Christian Geelhaar, October 16, 1978, *Writings*, 194).

52 On Johns' involvement with the "back" of things, see Richard Shiff, "Constructing Physicality," *Art Journal* 50 (spring 1991): 46–47; Joachim Pissarro, "Jasper Johns' Bridge Paintings Under Construction," in Garrels, 47–48.

would contradict this, such as the undisguised protrusion of the rectilinear wooden stretchers. The back numeral, when seen from the back of the canvas, is reversed with respect to left and right; and many of the tonalities reverse (where a detail on the front is white, the corresponding detail on the back may be black). When we imagine seeing through the canvas to its back, these reversals combine and reverse to a proper orientation. Given the actual opacity of *Figure 3*, we would need to turn the object by hand (it is small enough) to verify the relation of back to front. Or, instead of rotating the canvas, we could rotate ourselves.[53]

Self-rotation

In 1962, not long after Johns constructed *Figure 3*—and, presumably, mused over the parity question in relation to mirroring—he began to work on a project he called *Skin*. A sketchbook note circa 1960 lays out the problem:

> Make a plaster negative of whole head.
> Make a thin rubber positive of this.
> Cut this so that it can be (stretched)
> laid on a board fairly flatly.
> Have it cast in bronze and title it *Skin*.[54]

Johns enlisted his friend Jim Dine for the plaster negative "because he had just shaved his head." This initial attempt was "botched," and Johns decided not to pursue it further.[55] More successful were transfer images on drafting paper that Johns made by using his own head and in some instances other parts of his body. Photographer Ugo Mulas documented Johns' effort to displace his corporeal rotational volume onto a flat surface (fig. 12). Johns first oiled his face and head and then, with some stretching and straining, applied his head to the paper. Finally, he rubbed graphite over his oil imprint to develop a continuous image of the front, sides, and back of his head. The results, such as *Skin* (1965; fig. 13), resemble distorted mirror images but have been generated by a conjoining of rotation in space and rotation on a plane. Here Johns converted volumetric rotation into flat rotation without constructing an illusion in "space." His paper picture of skin is like skin itself—flexible enough to shift from three dimensions to two and back again. Whether three-dimensionally or two-dimensionally, whether actively or passively, *Skin* (or skin) both contains a figure and is a surface on which a figure can be projected.

Fill a Space Loosely

In 1964 Johns was struck by the type of manufacturer's disclaimer found on boxes of crackers and cereal. It advises the consumer not to expect the package contents to occupy the entirety

53 *Figure 3* is in the collection of the Yale University Art Gallery, where it hangs in a hinged frame that allows both sides to be viewed without the object being handled. The frame is not Johns' but was added to the work by a previous collector. In early 2000 Joachim Pissarro (then curator at the gallery) asked Johns about the appropriateness of the frame. He replied with a question reflecting his characteristic combination of preference and necessity: "How else might one show it?" (information courtesy Joachim Pissarro).

54 Johns, sketchbook note, circa 1960, *Writings*, 50–51.

55 Johns, interview by Roberta J. M. Olson, published November 3, 1977, *Writings*, 169.

fig. 12

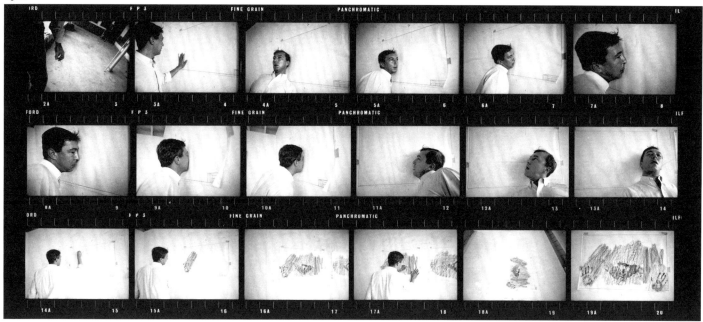

of the volume, for the product may have settled to the bottom. Implication: blame the potential deception on nature's law of gravity, not the manufacturer's intention—strange things happen. Johns' note in response to the situation seems to reflect on the irony of "fill[ing] a space loosely," whether with crackers or anything else.[56] He inserted a question mark after his own word fill, as if uncertain that the term made sense in this context. Can you fill a space (process) with no intention to make it full (end)? Can it be packed loosely as well as tightly? Experience with suitcases, drawers, and closets indicates the affirmative, but something is amiss in the language and the representational system. Work, the adage tells us, expands like a gas to fill all available time and space.

Working loosely brings advantages: flexibility, openness, time and space for more. Loose association is poetically generative and unending. But at a certain point—when?—it becomes the incoherent language of schizophrenia. One loosely packed configuration that Johns began to explore in 1984—a "rectangular face"—hasn't yet been mentioned despite its derivation from Picasso's *Woman with Straw Hat*, already discussed. Johns has explained the origin of this image in his work: "It interested me that Picasso had constructed a face with features on the outer edge. . . . It led me to use the rectangle of the paper as a face and attaching features to it."[57] As an imprint, he had already "attached" features to paper when he made his *Skin* series. Now he began with the fullness of a sheet of paper (perhaps including its edges and back) and

fig. 13

fig. 12 Contact sheet of photographs by Ugo Mulas of Jasper Johns creating *Skin* drawings, 1965 (detail)

fig. 13 Jasper Johns, *Skin*, 1965, charcoal, oil on drafting paper, 22 x 34 in. (55.9 x 86.4 cm), Private collection

56 Johns, sketchbook note, 1964, *Writings*, 58–59.

57 Johns, interview by Michael Crichton, late 1991 or early 1992, in Crichton, 71. Crichton (70) uses the designation "rectangular head," setting it in quotation marks, perhaps as Johns' own term; Roberta Bernstein refers to a "rectangular face," which seems more consistent with Johns' commentary (Bernstein, "'Seeing a Thing,'" *Retrospective*, 60). Touching on the question of fullness and emptiness, Bernstein (59) quotes a suggestive remark Johns made in conversation, May 21, 1996, as he reformulated an earlier statement on Picasso's *Woman with Straw Hat* (compare Johns, interview by Amei Wallach, published October 30, 1988): "[It appeared] very simple, arbitrary, and thoughtless, and yet . . . full of interesting thoughts." For Johns' pictorial notes on *Woman with Straw Hat* (1986?) and his "rectangular face" (circa 1990–1991), see *Writings*, 46–47.

regarded it as the flattened volume of a head, its front to be marked by features he invented, and filled by them, but loosely.[58] The face was stretched to occupy all available surface: "Take up the space 'with what you do,'" Johns had once written, puzzling over his definition of occupation.[59] Occupying the space in this manner, filling it, the face he drew appeared quite empty.

As both face and paper, Johns' Picasso figure could be either empty or full. Extended to the edges of a canvas, it provided space to be filled by his *Green Angel* (1990; cat. no. 29; p. 80). When Jane Meyerhoff, Johns' friend and collector, suggested "M. T. Portrait" as the title of an "empty" version—now known as *Untitled (M. T. Portrait)* (1986; fig. 14)—Johns accepted the designation, along with its play on the sound of the initials when spoken.[60] (In psychoanalytic terms, this would be a minor instance of "clanging"—an inappropriate or confusing association of meaning with sound—which sometimes accompanies racing thoughts.)[61] For *Untitled (M. T. Portrait)* Johns used his version of the Picasso face as an inset overlayer, or "figure," and the Grünewald demon as an enframing underlayer, or "ground." The work is a portrait in the sense that it represents the Picasso face at its center. Yet the same work lacks portraiture because the illusionistically represented sheet of paper, the "skin" with which the Picasso-like features are coextensive, has no image drawn upon it.[62] Were the "paper" full, it might be regarded as a double portrait, a duck-rabbit situation (as perhaps in *Green Angel*). Nevertheless, this enframed element of the painting pictures two things already, one rotating and one flat—a face and a sheet of paper.

One candidate for the missing "portrait," an image to fill the emptiness, appears in the encaustic painting *Untitled* (1991; cat. no. 40; p. 87) and in two closely related oil paintings—*Untitled* (1991; fig. 5) and *Untitled* (1991–1994)—as well as in their related prints (1995; cat. nos. 55–57; pp. 106–108). In the configuration shared by this group of works, an inset face (or facelike image, the "portrait") is illusionistically "nailed" to a rectangular "wall" or "panel," itself enframed by an outer border. Johns articulated the "wall" area with his version of the Picasso features, setting them at, or extending them toward, the edges of the surface. The features of the inset face are similar, loosely arranged within their own rectangle and either drifting toward the edges or, one might imagine, settling to the bottom like round or oval crackers in a box. Indeed, two "breasts," the largest of the drawn features, weight the portrait image toward the bottom. This anatomical identification is relatively secure because it derives from the source of Johns' inset image, a drawing to which I referred when discussing the "overthrow of parity" and "real difference." A schizophrenic girl under the care of Bettelheim rendered this drawing, titling her picture *The Baby Drinking the Mother's Milk from the Breast* (fig. 4). According to Bettelheim, the girl identified with both baby and mother and elsewhere drew herself "nursing herself." Perhaps the face belongs to both personalities, linked in the girl-artist, who "put [her] fingerprints all around the border."[63] Delusional multiple identity can be a feature of schizophrenia. When Johns appropriated the schizophrenic drawing, he retained the identifying fingerprints, but with the necessary shift; for the use of this mark specifies a single identity, the maker's. Fingerprints must "come that way," even in works that otherwise project multiple identity.

58 In 1995 Johns told Roberta Bernstein that the facial features were a free variation on Picasso's imagery rather than a direct derivation (Bernstein, "'Seeing a Thing,'" *Retrospective*, 60).

59 Johns, sketchbook note, 1964, *Writings*, 55.

60 For an account of further nuances in the naming, see Mark Rosenthal, "Jasper Johns," in Mark Rosenthal, ed., *The Robert and Jane Meyerhoff Collection 1945–1995* (Washington D.C.: National Gallery of Art, 1996), 82, 86.

61 On clanging or clang associations: Allen Frances, ed., *Diagnostic and Statistical Manual of Mental Disorders* (Washington D.C.: American Psychiatric Association, 2000), 358; Eugen Bleuler, *Dementia Praecox or The Group of Schizophrenias*, Joseph Zinkin, trans. (New York: International Universities Press, 1950 [1911]), 25. Coincidentally, the Robert

and Jane Meyerhoff collection includes the oil version of Johns' *Racing Thoughts* (1984).

62 An earlier work, *Untitled (A Dream)* (1985), reverses the relationship of the Picasso face to the Grünewald demon.

63 Bettelheim, "Schizophrenic Art: A Case Study," 34. Bettelheim himself viewed the image with less ambiguity: "This was a pictorial world that consisted only of the mother's breasts and, just above them, what the nursing infant sees—mouth and eyes."

fig. 14

By a loose, half-conscious sequence of thoughts, Johns moved from the Picasso face back to the Bettelheim face, which he vaguely remembered having seen around the time it was originally published in 1952: "I associated my memory of the child's drawing with my paintings showing eyes, nose and mouth distributed at the edge of a rectangle, no later than 1988, possibly as early as 1984."[64] Why 1984? Because 1984 is the year Johns began to use the "rectangular face." It remains possible that his interest in the Picasso imagery derived from his buried memory of the Bettelheim face, rather than the reverse. Here Johns seems to experience a biographical version of a duck-rabbit. Was his mind's eye actually focused on Bettelheim or on Picasso? He cannot determine. He has speculated, however, that when "something can be seen in two different ways," even the problematic duck-rabbit, "it may be possible to see both at once."[65] In 1991 Johns sought out the Bettelheim drawing in *Scientific American*, rediscovering it.[66] From that point on, with the precise configuration of the schizophrenic image in hand, he could relate, rather than conflate, his two loosely associated visions. He could actively choose between them, whether seeing them at once or not. And he could freely substitute other images, as he did in the monotype *Untitled* (1996; cat. no. 59; p. 110), with its inset Mona Lisa and superimposed handprint, mirrored.

"How my mind *must* move," Johns says. It moves because sensations, thoughts, and memories fill it only loosely, without fixed causal connections. A mind doesn't become full. In recent years Johns has been using a paradigmatic figure for his creative looseness—the spiral galaxy. Its familiar configuration of stars expands, contracts, rotates, and occupies a vast space without filling it. By some accounts, a spiral galaxy "flattens into a thin disk," nevertheless maintaining its expansiveness.[67] In *Mirror's Edge* (1992; fig. 1; p. 41), Johns combines the galaxy with other images of rotation, reversal, and cosmic order, including his cruciform version of *The Seasons* (1990; cat. no. 30; p. 76). The astrological calendar of the annual seasons can be rotated; convention alone dictates that spring marks the beginning. The structure of Johns' *Summer Fall Winter Spring* (2000; cat. no. 71; pp. 122–123) implies that its sequence revolves, its left-right order becoming arbitrary.[68] It would be immensely difficult, however, to counteract the logic, science, and poetry that have perennially set the origin of life to spring. Thinking otherwise would seem particularly willful, even deranged. Yet life is loose, and space remains to be filled with imagination. If nature always begins with spring, it merely "comes that way." Like other preferences Johns has probed, his as well as nature's, this one has no cause.

For essential aid in research, I thank my assistant James Lawrence, as well as Jasper Johns, Leo Steinberg, Richard Field, Joachim Pissarro, and Susan Greenberg.

Richard Shiff is the Effie Marie Cain Regents Chair in Art at the University of Texas at Austin, where he directs the Center for the Study of Modernism. Author of *Cézanne and the End of Impressionism* (1984) and coeditor of *Critical Terms for Art History* (1996, 2003), he publishes widely on modernist modes of representation in the art of the nineteenth and twentieth centuries.

fig. 14 Jasper Johns, *Untitled (M. T. Portrait)*, 1986, oil on canvas, 75 x 50 in. (190.5 x 127 cm), Collection Robert and Jane Meyerhoff, Phoenix, Maryland

64 Johns, statement to Jonathan Fineberg, September 20, 1994, in Jonathan Fineberg, *The Innocent Eye: Children's Art and the Modern Artist* (Princeton: Princeton University Press, 1997), 223. See also Johns, interview by Amei Wallach, February 22, 1991, *Writings*, 260.

65 Johns, interview by Mark Rosenthal, September 2, 1992, *Writings*, 283.

66 Bernstein, "'Seeing a Thing,'" *Retrospective*, 60. See also Field, 33–34.

67 Jan H. Oort, "The Evolution of Galaxies," *Scientific American* 195 (September 1956): 108. During the 1950s, images of spiral galaxies cohabited *Scientific American* with Bruno Bettelheim, mirrors, and the parity problem.

68 Compare Bernstein, "'Seeing a Thing,'" *Retrospective*, 65. The actual sequence in which Johns first created his *Seasons* imagery during 1985–1986 was *Summer, Winter, Fall, Spring*.

What Do You See?
Jasper Johns' Green Angel
Joan Rothfuss

On April Fool's Day, 1990, working in his studio on the island of St. Martin, Jasper Johns made several untitled drawings of a peculiar, rather inelegant motif now known as Green Angel (fig. 1). It's made up of two flatly patterned, irregular forms—one laid at a right angle to and seemingly atop the other—in an indeterminate background space. One has the sense that the motif is figurative, partly because of its overall vertical orientation and the lumpen, organic outlines of its components, but also because of the strong figure-ground nature of the compositions in which it is used. So far, Green Angel has made an appearance in more than forty paintings, drawings, and prints, dating from 1990 to 1998. This body of work is one of the most curious Johns has yet produced: despite the many cues that encourage us to see the motif as more than just a random arrangement of line and color, Green Angel resists positive identification as anything in particular. Instead, it hovers enigmatically between illusion and abstraction.

Our intuition that Green Angel *is* something is confirmed when we learn that Johns derived the motif from a tracing of another image.[1] Quotation of this sort is one of his standard methodologies, but in this case the source is unknown and, for the first time, he has refused to reveal it. As a mystery, Green Angel is both fascinating and aggravating—it compels us to ask "What is it?" If we know it to be a direct copy of something, we expect it to represent that thing in a legible way. Yet it remains completely opaque, like a sentence written in a language we cannot read. Green Angel makes us all into illiterates, renders us infantile, and it's difficult not to be annoyed by this, especially if one attributes the withholding, as some critics have, to artistic whim.

But Johns has explained his reasons for concealing his source, and they are not capricious.

> I got tired of people talking about things that I didn't think they could see in my work. . . . It interested me that people would discuss something that I didn't believe they could see until after they were told to see it. And then I thought, what would they have seen if they hadn't been told about these things, because the same painting is there. And when I decided to work with this new configuration [Green Angel], I decided I wasn't going to say what it was or where it had come from. One of the things that interested me was that I knew I couldn't see it without seeing it, seeing *that*, because I knew, and I knew that someone else wouldn't know and wouldn't see, and I wondered what the difference was in the way we would see it. And, of course, I'll never know . . .[2]

Though it may have been born out of irritation with our often-careless viewing habits, Johns' tactic also derived from his pure curiosity about how and why we see what we see. By withholding the key to Green Angel's provenance, he forces us to remain in a position of ignorance—but only so that we can have an encounter with the image that he can never have. In fact, this is an entirely new kind of perceptual experience: a representation that must be seen in isolation from any understanding of the thing it represents. The explanation above ends on a wistful note, suggesting that Green Angel contains a question: Here is this peculiar image;

fig. 1 Jasper Johns, *Untitled*, 1990, oil crayon, pencil, watercolor on paper, 17⅝ x 13½ in. (44.77 x 34.29 cm), Collection the artist

1 Johns revealed this in an interview with Amei Wallach, February 22, 1991. Reprinted in Kirk Varnedoe, ed., *Jasper Johns: Writings, Sketchbook Notes, Interviews* (New York: Museum of Modern Art, 1996), 259.

2 Ibid., 260.

fig. 1

would you tell me what you see? This essay offers some thoughts.

One Image After Another

Critics have been assiduous about mining Johns' images for iconographic sources. He has encouraged this, in a way, because many of his motifs—the U.S. flag, the Mona Lisa, an abstracted flagstone pattern, and others—are quotations or appropriations of preexisting images. Among these are several made by tracing reproductions of works by other artists, a practice he seems to have begun in the late 1970s with a copy after a Cézanne painting. In 1981 he made tracings of two figurative details from Matthias Grünewald's Isenheim Altarpiece (circa 1512–1516): a soldier who has been felled by the glory of Christ's resurrection, and a diseased, bloated man/demon who appears in St. Anthony's hallucinatory visions (figs. 2–3). Johns has included outlines of these figures in dozens of works: a brightly patterned version of the soldier is a key motif within *Mirror's Edge* (1992; fig. 1; p. 41); the man/demon appears as a ghostly image floating in the background space of *The Bath* (1988; fig. 7; p. 21) These motifs, at first unidentified, were puzzling to viewers. They clearly indicated something specific, but the referent was illegible. Johns intended this: as he later explained, he was interested in the articulation of the figures as line in space. "Looking at [reproductions of the Isenheim Altarpiece], I thought how moving it would be to extract the abstract quality of the work, its patterning, from the figurative meaning. So I started making these tracings. Some became

JASPER JOHNS
TERRES BASSES
MARIGOT
ST. MARTIN, F.W.I.

1 April 1990

fig. 2

fig. 3

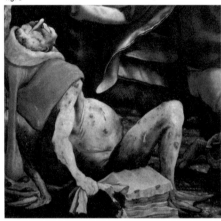

figs. 2–3 Matthias Grünewald, Isenheim Altarpiece, circa 1512–1516 (detail), oil on wood, Collection Musée d'Unterlinden, Colmar, France

illegible in terms of the figuration, while in others I could not get rid of the figure. But in all of them I was trying to uncover something else in the work, some other kind of meaning . . ."[3]

What other kind of meaning could he have been imagining? Separating the physical structure of a thing from its associative meaning is simply another way of decontextualizing it, and that is usually understood to diminish the richness of the thing. But must isolation always be reductive? Maybe Johns wants simply to free these motifs from the established ways of seeing and therefore thinking about them. Ludwig Wittgenstein gives an example that suggests how familiarity with a thing might change how one sees it: "I meet someone whom I have not seen for years; I see him clearly, but fail to know him. Suddenly I know him, I see the old face in the altered one. I believe that I should do a different portrait of him now if I could paint."[4] Knowing a thing in advance of seeing it alters one's perception of it, obscuring certain aspects and accentuating others. Wittgenstein goes on to speculate that the act of "recognition" is an amalgam of seeing and thinking, and imagines other situations in which the two activities might be prized apart.

Recycling the Grünewald details, Johns gives us his own proposal. The images—taken from an old friend in the art-historical canon, one we may not have seen for years—are secondary motifs that have been wrenched from their context, inserted in larger compositions, and have undergone various changes along the way: they've been enlarged, reversed, rotated, cropped, stripped of color, and/or are missing much of their detail. These changes make it very unlikely that anyone would recognize them without some assistance. Instead, we see them as configurations of line that seem to represent something, but may not. (This was the case, at least, before their sources were revealed.) Knowing that we are caught between seeing and recognizing is uncomfortable, especially for those of us trained in Panofsky's iconographical method of art history (which Johns' work of this period both recommends and frustrates). During the 1980s, some of Johns' critics responded to these new motifs by working very hard to identify their sources and thus complete the act of recognition.[5] As a result, the Grünewald motifs are now legible within Johns' work; one writer has even remarked that it is now "hard to remember . . . how it was not possible to see the outline in the first place."[6]

In summer 1989 Johns added two new motifs to his vocabulary of imagery. Working from a poster for an exhibition he had visited the previous year, he made tracings of a drawing by Hans Holbein the Younger, *Portrait of a Young Nobleman Holding a Lemur* (circa 1541) (cat. no. 27, p. 79). About six months later, he produced the first Green Angel tracing (fig. 4); soon after that he made paintings using each of the motifs. Neither painting was linked to its source by language: one was left untitled, and the other was named *Green Angel* (fig. 5).

Because of the way we are trained to look at pictures, the relationship of title and image will be one of the first riddles posed by Green Angel. The figure is not green, and one can't make

3 From an interview with Richard Cork, November 30, 1990. Reprinted in Kirk Varnedoe, ed., *Jasper Johns: Writings*, 258.

4 Ludwig Wittgenstein, *Philosophical Investigations*, trans. G.E.M. Anscombe (Oxford, England: Blackwell Publishers, 1953), 197e.

5 See especially Jill Johnston's two articles, "Tracking the Shadow," *Art in America* 75, no. 10 (October 1987), 128–143, and "Trafficking with X," *Art in America* 79, no. 3 (March 1991), 103–111, 164–65. According to critic Mark Rosenthal (see his book *Jasper Johns: Work since 1974* [Philadelphia: Philadelphia Museum of Art, 1988], 106, n. 19), the presence of the soldier in *Perilous Night* was first noted by John Yau in "Target Jasper Johns," *Artforum* 24, no. 4 (December 1985), 84–85; Johnston discovered the presence of the man/demon in "Tracking the Shadow."

6 Jill Johnston, *Privileged Information* (New York: Thames and Hudson, 1996), 43.

fig. 4

fig. 5

fig. 6

out any resemblance to conventional renderings of angels. This is counterintuitive, as we expect the verbal and visual elements of a painting to operate in tandem to clarify meaning, whether in a literal or a poetic way, but neither relationship is obviously at work here. Knowing of Johns' interest in and application of language in his work only increases the confusion. When asked how the painting had been named, he offered an oblique explanation: "I think there is a peacock-crowned figure in the Isenheim Altarpiece which is often referred to as 'the green angel.'"[7] This figure, which is clearly not the source of Johns' motif, is indeed a green angel—a relatively minor one that appears in the *Concert of Angels—Nativity* panel of the altarpiece (fig. 6). It is apparently just odd enough, or just unexpected enough, to have stimulated considerable speculation on its meaning among Grünewald scholars.[8] Specifics of those arguments are not germane to Johns' motif, but the interpretive situation is parallel: the figure provokes some puzzlement among viewers, even those schooled in the artist's work. In a larger sense, Johns' choice of *Green Angel* as a title underlines the arbitrary nature of the relationship between language and things. It mimics the Surrealists' tactic of pairing incongruous verbal and visual elements in order to increase the possible meanings of a work rather than offer easy closure. In this way it is, we will find, an augury of the way the image itself functions: it intentionally diverts understanding—at least of the conventional kind.

fig. 4 Jasper Johns, *Untitled*, 1990, ink on plastic, 41 ¾ x 31 ⅜ in. (106.05 x 79.69 cm), Collection the artist

fig. 5 Jasper Johns, *Green Angel*, 1990 (cat. no. 29; p. 80)

fig. 6 Matthias Grünewald, Isenheim Altarpiece, circa 1512–1516 (detail), oil on wood, Collection Musée d'Unterlinden, Colmar, France

7 Correspondence with the author, March 3, 2003

8 Writers on Grünewald have interpreted the "green angel" figure as the "carnal spirit of darkness"; the symbol of hope in the trinity of faith, hope, and charity; and a representation of the fallen angel Lucifer. See Horst Ziermann, *Matthias Grünewald* (Munich: Prestel, 2001); Linda Nochlin, *Matthias at Colmar: a Visual Confrontation* (New York: Red Dust, 1963); and Ruth Melinkoff, *The Devil at Isenheim: Reflections of Popular Belief in Grünewald's Altarpiece* (Berkeley: Univ. of Calif. Press, 1988).

fig. 7

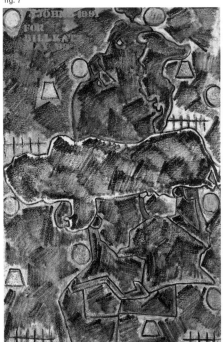

When Johns introduced the Holbein and Green Angel motifs, he immediately used them in a completely new way. No longer background patterns, the new motifs fully occupy the foreground space and are obviously the principal subjects in each work. *Untitled* is clearly a figure, presented in a formal pose that suggests it is a portrait, although the absence of facial features renders it meaningless as such. (Or does it? Can a person's character be conveyed through posture, clothing, and attributes alone? Traditional images of saints rely on no more than these to cue the viewer to the subject's identity. Or is a specific outlined shape enough? Johns might have been signaling his interest in such questions by using his own shadow self-portrait in *The Seasons* paintings of 1985–1986, or by choosing a punning title for his 1986 oil *M. T. Portrait* [fig. 14, p. 25], whose near-empty picture plane seems to be waiting for a subject while stylized eyes peek over its edges, watching.) Many later works using the motif are titled, baldly, "after Holbein," a designation that eliminates speculation about either source or process.

Compared to *Untitled*, *Green Angel* offers quite a bit less guidance. It seems to be figurative, but inconclusively so; the facial features around its perimeter—the same ones that appear in *M. T. Portrait*—add a note of dreaminess to the conventional figure-ground pictorial space. In these images about perception, the painted eyes are particularly suggestive: Who is looking, and what is being seen? From the viewers' side of the picture plane, the motif is an empty portrait, highly specific yet drained of information, like a cast-off skin. Could it be read as a memento mori? Remember that Johns imagined that the artistic act of separating the figurative from the abstract—or the body from the spirit—might be somehow "moving." If we think of his traced outlines as bodies stripped bare, as bones without flesh, then this odd choice of words is less puzzling. A painting of 1991 may provide a clue in this direction (fig. 7). The cartoonish facial features have been replaced by numerous schematic shapes that suggest the "features" of a skull: circular eye sockets, a trapezoidal nose opening, and a hatchmark to indicate a toothy death's grin.

While Johns introduced the Holbein and Green Angel motifs into his work at roughly the same time, he has seemed more interested in developing the latter. After two years of intensive exploration, Johns began using it in larger compositions as an image that represents itself but also signifies "a painting." Or, more precisely, "a Johns painting." In a dozen works made since 1991, he has drawn Green Angel within a framed shape that suggests a reclining plane. In the earliest of these, two drawings and a lithograph dated 1991 or 1992, the plane is actually rendered as a stretched canvas that's been turned to the wall; apparently showing through from the front are Johns' stenciled signature and a ghost image of Green Angel (fig. 8). This seems to confirm that we are looking at this motif from behind, and that Johns himself has turned the canvas to the wall; its position limits our ability to perceive it for what it is, and at the same time opens an impossibly broad field of possible interpretations.

fig. 7 Jasper Johns, *Untitled*, 1991, encaustic, sand on canvas, 42 ³/₁₆ x 28 ¹/₁₆ in. (107.16 x 71.28 cm), Private collection, New York

fig. 8 Jasper Johns, *Untitled*, 1992, watercolor, ink on paper, 41 ¹/₂ x 27 ¹/₂ in. (105.41 x 69.85 cm), Private collection

Distinctness Plastically Felt

Johns is known for his brilliant use of color and his virtuoso painterly gesture, but many of his motifs are essentially linear. Flag, target, numerals, letters—all can be understood as line drawings. Silhouettes, shadows, and tracings have appeared in his work with some regularity, and imprints of three-dimensional objects are often present on the (flat) surfaces of his works. The latter leave either a recognizable outline or silhouette—an iron, hands, feet, a torso—or a mysterious marking with an obvious, though illegible, relationship to some three-dimensional object.[9] All of these conform to Johns' stated interest in preexisting rather than invented images.

The Green Angel motif belongs to this class of imagery: as noted, it is a tracing. Perceiving it involves moving one's eyes around a set of contours that we understand as signifying the end of one kind of space and the beginning of another. To describe it, we might say that it is composed of two irregular forms, one horizontal and one vertical (hereafter referred to as shape H and shape V). Both are divided internally into segments, and shape H seems to rest on top of shape V, thus appearing closer to us. Their relationship remains constant, whether mirrored, flopped, turned upside down, or shown in close-up, although in a few instances Johns has detached shape H and made it the subject of a drawing or painting on its own.

Occasionally he seems to vary Green Angel's outline, as in a stark painting of 1990 in which shape H is isolated against a hanging

fig. 8

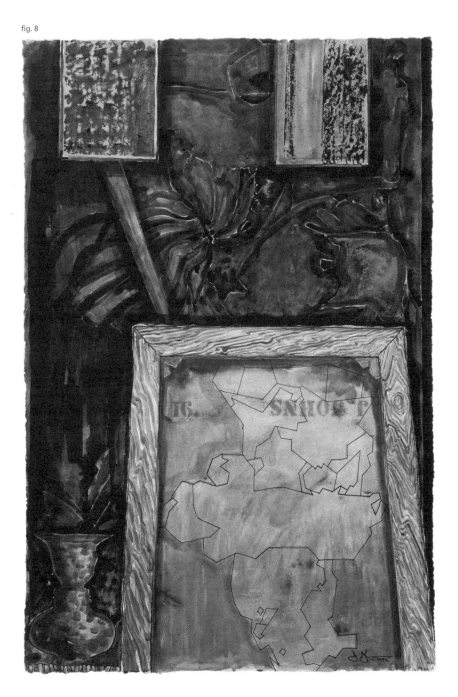

9 This is the case, for example, in Johns' painting *No* (1961), which includes an imprint of Duchamp's *Female Fig Leaf* on its surface.

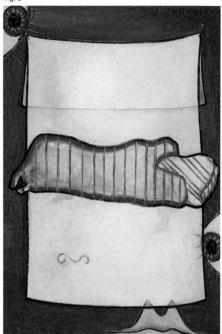

fig. 9

cloth that takes the place of shape V (and suggests that the former is of greater importance than the latter; fig. 9). If one is familiar with the Green Angel motif, one notices immediately that the lower protuberances of shape H have apparently been lopped off. It's a relief to discover their faint outlines in the familiar positions, obscured underneath the cloth backdrop. (This is odd: Does Johns mean to suggest that shape H is a solid mass that's been sundered by a spectral cloth? Or that we're looking at a solid cloth with two holes that accommodate the passage through of shape H's lower appendages? From here, we could be reminded of the surrogate vagina to which Johns alluded in his "dutch wives" works of the 1970s. Why not even a performance score by Nam June Paik, with whom Johns was acquainted in the mid-1960s. Paik's *Young Penis Symphony* (1962) calls for ten men to stick their penises through a hanging paper curtain. Is Johns' painting an image about absence, longing, unfulfilled desire? As the piercing is being witnessed by the disembodied eyes and lips—which are clearly indicated to be behind the cloth—are we watching a scene of voyeuristic display, from behind?)

In the example above, the outline only seems to have changed. (By trying and failing to alter the contour, he seems to be reminding us that certain things are unchangeable, despite our desires. Is it too much to infer from this that Green Angel is in part a melancholy notation about the ultimate isolation in which we all exist?) At other times, Johns says, he has "deliberately distort[ed] some element [of the tracings] in order to adjust or alter the composition."[10] This is clearly what has happened to the lower portion of shape V in several Green Angel works: its interlocking segments have been added and removed to form different combinations. Three variations (there are others) can be seen by comparing an early drawing, a painting of 1991, and a delicate intaglio of 1998 (figs. 10–12). If one has the chance to examine this section of the motif in several works, however, it becomes clear that the relationship of parts is constant: they only fit together in one way, as in a jigsaw puzzle, and again, what at first seemed random is shown to be constant—or at least subject to a quantifiable set of variations. (Here we might also ask why Johns has chosen to vary only the lower edges of both figures, allowing them to fade in and out of view, so to speak. Is he giving us a clue about the relative importance of those sections of the motif? Or is he making a punning point about Green Angel's literal lack of "grounding" that also suggests its interpretive instability?)

Johns has said that he is interested in "the degree to which [things] can be changed in some way and yet remain what they are."[11] In these traced images he has chosen the isolated outline as his constant, perhaps because an outline can be of limited use in understanding a shape. It describes a perimeter, but no more and no less than a perimeter. On its own, it isn't part of a larger system of information that describes a volume (the kind of outline to which, as Heinrich Wölfflin charmingly described it, "the spectator can confidently entrust himself."[12]) In fact, an outline might even be misleading, because the activity that happens at the edges of a form may or may not be useful in understanding its essential character. If one traced a photograph of a flag waving in the wind, the outline alone may not be recognizable as an image of a

fig. 9 Jasper Johns, *Untitled*, 1990, oil on canvas, 37 ⅛ x 25 ¼ in. (94.3 x 64.14 cm), Collection the artist

10 Johns in a letter to the author dated March 2, 2003.

11 In an interview with Amei Wallach, *Writings*, 260.

12 Heinrich Wölfflin, *Principles of Art History*, M. D. Hottinger, trans. (New York: Dover, 1950), 19.

fig. 10 fig. 11 fig. 12

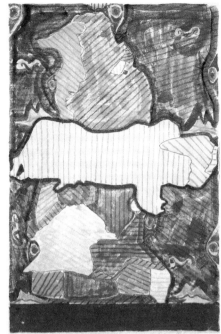
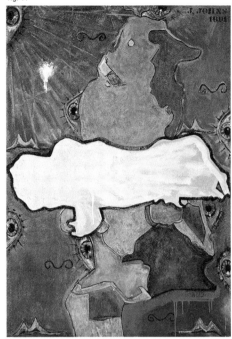
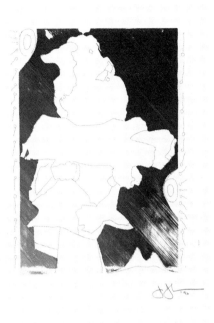

flag, yet it would unquestionably be one. Green Angel exploits this ambiguity: its outline, though trustworthy, doesn't help us understand what the shape signifies because we're unable to distinguish the incidental information from the essential.

This leads us to wonder what kind of information is actually essential to the perception of a thing. Does the outline of a flag flying in the wind really present a less truthful portrait of a flag than a simple rectangle, which could in fact describe many things? One might say that since the former communicates context and function, such an image is more fully truthful than the latter. To cite Wölfflin again, linear representations are objective renderings of the world that forsake artistic adjustments, even those that might lead the viewer to a clearer reading of the image.[13] One could apply Wölfflin's description to maps: they are nonnegotiable contours, useless without unwavering truth to a thing outside themselves. Maps are on some level images about absence because they describe places in which you are not present. Green Angel's consistent contours make it a kind of map, although its borders are the only information we have about its terrain. How can we navigate what we don't understand?

The division of figure and ground is an established formal device used to indicate an object in space. The most radical (or obvious) way to accomplish the division—used to great effect by

fig. 10 Jasper Johns, *Untitled*, 1990, watercolor on paper, 38⅝ x 25⅜ in. (98.18 x 64.45 cm), The Museum of Modern Art, New York; Partial and promised gift of UBS PaineWebber

fig. 11 Jasper Johns, *Untitled*, 1991, encaustic, sand on canvas, 50⅞ x 35⅝ in. (129.22 x 90.49 cm), The Eli and Edythe L. Broad Collection

fig. 12 Jasper Johns, *Green Angel*, 1998 (detail), etching on paper, 24 x 18 in. (60.96 x 45.72 cm), Collection Walker Art Center, Minneapolis; Gift of the artist, 2000

13 Ibid., 20. "[Draughtsmanly representation] represents things as they are, [painterly representation] as they seem to be."

fig. 13

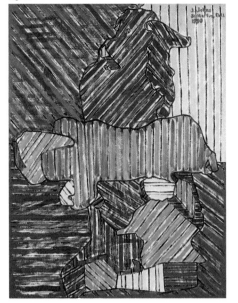

fig. 14

Édouard Manet, Diego Velázquez, and countless anonymous icon painters—is to float the figure on a monochromatic, indeterminate field of color, and Johns uses this strategy in several works—including some in which the color field is green rather than any portion of the so-called Green Angel (fig. 12). Alternately, in a vibrant 1990 oil on canvas (fig. 13), figure and ground alike are partitioned into brightly colored, striated segments, but the background reads as such because it is indicated by a quadrant of shapes that are defined either by the edge of the canvas or by the contours of the Green Angel itself.

We know that Johns has been interested in how figure-ground functions in perception because he has used several variations on an image that is iconic in that field of study, the so-called Rubin's vase. Developed by Danish psychologist Edgar Rubin, the motif can be read either as a vase or as two faces "looking at each other," but not as both simultaneously. This visual effect—known as figure-ground reversal—depends on a shared contour and allows the areas defined by the outline to be perceived as a figure "even when the figure does not look like any known thing."[14] Green Angel is not a demonstration of figure-ground reversal, but rather an image that is easily read only one way. Johns plays with this stability in a 1990 drawing in which Green Angel's shape H becomes part of his own variation on the Rubin's vase image (fig. 14).

The division between figure and ground is least discernable in the first rendering Johns made of Green Angel, an ink on plastic drawing presumably traced directly from the source (see fig. 4). This is true of other traced images, as well, and is perhaps significant: one wonders whether the gap is meant to establish as much distance as possible between these first-generation copies and their antecedents, releasing them from their cramped condition as no more than copies of something else. His choice of ink on plastic—a curiously imprecise technique for a copying exercise—supports this hypothesis. The drawings are almost palpably luxurious in their rich tonal variation, and contain a sensuous energy that seems to arise from the struggle between incompatible materials: the ink is repelled by the relatively impenetrable surface of the plastic and eventually settles where it can, making gorgeously feathered and mottled puddles. The element of chance in this process gives the drawings a quality of "independence" from his touch that appeals to Johns, as it results in a finished work in which "it is difficult to tell . . . what gestures were used to produce it."[15]

Picture Puzzles

If illusion in painting is the presentation of understandable or believable depictions of the outer world, Johns' Green Angel is certainly non-illusionistic, even subversively so. Its inclusion in the untitled lithograph of 1992 mentioned above seems to underscore this (fig. 15). The print—which clearly references trompe l'oeil compositions by artists such as John Peto and William Hartnett as well as Johns' concurrent painting *Mirror's Edge*—is a complex layering of images

14 Quoted in Richard Gregory, *The Intelligent Eye* (New York: McGraw Hill, 1970), 16–17.

15 Quoted in Nan Rosenthal, et al., *The Drawings of Jasper Johns*, exh. cat. (Washington, D.C.: National Gallery of Art, and New York: Thames & Hudson, 1990), 73.

fig. 15

over and within other images in a shallow pictorial space. The central shape depicts a sheet of paper, its corners curling up in a stylized manner, that is taped to a flat surface in six spots. This "paper" in turn bears a depiction of four objects: two Barnett Newman drawings that Johns owns; a "Rubin's vase" with profiles of Queen Elizabeth II and Prince Philip; and the top portion of a stretched canvas on which there is a faint rendering of Green Angel. The background space is occupied by a rather florid version of the Grünewald soldier motif. Although it is not highly illusionistic, the drawing on the curling paper still reads as a group of objects in space: the dimension of the vase is suggested by some perfunctory modeling, and the stretcher is shown in perspective to suggest a leaning position. Yet, on their own, each of these objects could be said to destabilize the notion of perceptual illusion: Newman's black-and-white works are abstractions; the trick vase allows for two equally valid readings; and the Green Angel motif is an illegible mystery. Even the background pattern—the Grünewald detail—is decontextualized and virtually unidentifiable. To double his subversion of illusion, Johns has drawn each object from a point of view other than that intended originally by its maker. The Newman drawings are mirror images (a reversal that also references the process of printmaking itself); the vase is inverted; the Green Angel is upside down on the reversed canvas—assuming, of course, that he presents it "right-side up" in all other versions, and that his signature is oriented correctly—and the Grünewald detail is rotated and flopped from its orientation in the original. As an inventory of alternative positions (upside down, backwards, mirrored, sideways), *Untitled* reminds us that illusion sometimes depends upon maintaining a particular point of view. Johns proposes looking at things from other directions.

Johns' work has consistently been involved with the notion of shifting or alternative points of view. Among the Green Angel works there are several curious representations that play with this theme and even seem to allude to anamorphoses—trick images in which a shape appears illegible or distorted from the conventional point of view but becomes recognizable when seen from one (and only one) unorthodox point of view.[16] Sometimes the transformation is accomplished by viewing the image from an extreme angle, often through a pinhole drilled in the frame; others require the aid of a flat or curved mirror held at a specific angle. Johns' variations recall this latter technique, but they offer us both the distorted and corrected versions in one image. In a drawing of 1996, for example (fig. 16), the Green Angel is presented along with what seems to be a mirror image that is illusionistically rendered to suggest that it's being reflected back at an angle and affected by atmospheric perspective (the form is compressed, the contours softened, and the colors lighter in tone). Johns drew a line marking the point at which the "real" image stops and the mirrored one begins—a kind of horizon line that clearly suggests spatial depth. (The presence of the enormous, staring eyes and the allusion to a watery reflection recall the story of Narcissus; could Johns here be reminding us of the solipsistic nature of his motif?) If this is an anamorphosis, the top image, which appears "correct," is actually a reflection; this would of course be reversed in a standard representation. Being given two possibilities about which end is up, so to speak, leaves the viewer without

fig. 13 Jasper Johns, *Untitled*, 1990, oil on canvas, 33¼ x 25¼ in. (84.45 x 64.14 cm), Collection the artist

fig. 14 Jasper Johns, *Untitled*, 1990, watercolor, pencil on paper, 22¼ x 17¾ in. (56.52 x 45.09 cm). Private collection

fig. 15 Jasper Johns, *Untitled*, 1992 (cat. no. 46; p. 95)

16 Richard Shiff has discussed anamorphosis in relation to Johns' work in "Anamorphosis: Jasper Johns," in *Foirades/Fizzles: Echo and Allusion in the Art of Jasper Johns* (Los Angeles: Wight Art Gallery, University of California, 1987), 147–166.

fig. 16

fig. 16 Jasper Johns, *Untitled*, 1994 (cat. no. 53; p. 103)

clear direction on how to look at this image. Confusion is eliminated in three related monotypes of 1996: Johns removes the dividing line and unites the distorted and corrected versions in one large shape; he then adds circular imprints along the bottom edge. These changes flatten out the picture plane and reinstate a standard, straight-on point of view (fig. 17).

As variations on the system of one-point perspective, anamorphoses are intimately connected to the tradition of illusionism developed in the Renaissance. Green Angel references illusion only to subvert it, but it cannot be considered an abstraction either, although it effectively functions as one. Compare it, for example, to Ellsworth Kelly's work: his abstractions are based on the world of objects, but the sources are subjected to a process of distillation that buries them deeply within the finished compositions. In a way, Green Angel is an image about this transformation; as its sections shift or fade in and out of view, its contours become more or less detailed, and it gains or loses coloration. One might almost imagine that one is watching a physical struggle as the motif attempts to achieve some kind of clarity. But whether the movement is away from the illusionistic or toward it is unclear.

In an essay on the interpretation of images, psychologist Richard Gregory described a perceptual state of limbo known as the retinal image, or the image as it exists in the eye:

> As pictures, retinal images are very odd—unique—for although they are indeed perspective pictures of the world, they are never seen, for there is no eye looking at them and so they are not objects of perception. They are, rather, just one cross-section on the pathway from objects to perceptions of objects.[17]

This may be a useful way to think about Green Angel: picture it frozen, somewhere between its source and our understanding. It is undeniably visible, but cannot really be seen. We could even think of it as a kind of obstruction, a roadblock on the way to cognition. As we attempt to move past the barrier—that is, to understand what we are seeing—we are transformed into active viewers. As Gregory notes, the energy expended in the effort to perceive unusual images helps overcome the "inertia of wisdom"—an unbecoming situation in which we allow what we already know to block our view.[18] Green Angel may cause us turmoil, but that is not always a bad thing. As Johns has noted, "When something is new to us, we treat it as an experience. We feel that our senses are awake and clear. We are alive."[19]

The above observations are possible because for this writer the Green Angel's source remains a mystery, and I began this essay by noting that Johns can never have that kind of confrontation with Green Angel. But he has had a similar experience with another artist's work. As he recalled to an interviewer in 1991 (a year of intense involvement with the Green Angel motif), he had become curious about the genesis of Marcel Duchamp's oddly shaped bronze multiple

17 Richard Gregory, "How do we interpret images?," in *Images and Understanding: Thoughts about Images, Ideas about Understanding, a collection of essays based on the Rank Prize Funds' International Symposium*, 1986; Horace Barlow, Colin Blakemore, and Miranda Weston-Smith, eds. (Cambridge: Cambridge University Press, 1990), 310.

18 Ibid., 329.

19 Quoted in Calvin Tomkins, "The Changing Picture: A Retrospective Reveals Jasper Johns," *The New Yorker*, 72, no. 34 (November 11, 1996), 124.

fig. 17

Objet Dard (1951), of which he owns an example. "I could never understand how anyone could come to make that particular object; I couldn't understand out of what it would come, out of what thought process you would arrive at this form. Once I asked Marcel . . . and he simply smiled, puffed on his cigar, and wouldn't tell me." Johns later learned—he thinks from Duchamp's widow, Teeny—that *Objet Dard* was cast from a brace for the mold for *Étants donnés . . .* (1946–1966), Duchamp's last work. Though Johns says he isn't sure that the information changed his perception of the object, he also acknowledges that he can no longer think of it without thinking of its source as well. This understanding led him to consider "the importance of the thing itself, freed from information [about its source]."[20] Maybe this experience led him to the idea to offer up his own riddle. Should we ask him about its source, he does us the favor—as Duchamp had done for him—of electing not to answer.

Joan Rothfuss is curator of the permanent collection at the Walker Art Center, where she has worked since 1988. The numerous exhibitions she has organized include 2000 BC: THE BRUCE CONNER STORY PART II (1999), *Joseph Beuys Multiples* (1997), *On a Balcony (Mark Luyten)* (1997), and *In the Spirit of Fluxus* (1993). Her published writings include essays on Joseph Beuys and Yoko Ono, and she is currently working on a biography of avant-garde cellist Charlotte Moorman.

fig. 17 Jasper Johns, *Untitled*, 1996 (cat. no. 60; p. 104)

20 See Wallach, *Writings*, 265.

Three Academic Ideas
Victor I. Stoichita

In a statement published in 1959, Jasper Johns described "three academic ideas" that were of interest to him. The first, mentioned by one of his teachers, was "the rotating point of view." The second originated from Marcel Duchamp: "To reach the Impossibility of sufficient visual memory to transfer from one like object to another the memory imprint." The third is attributable to Leonardo da Vinci: "The boundary of a body is neither a part of the enclosed body nor a part of the surrounding atmosphere."[1] This declaration by the artist does not constitute a rigid program, but it does provide insight into some of the culturally codified explanations and foundations upon which his work has been constructed over the years.

It seems to me that traces of these three ideas can be found—intertwined, superimposed, and intermingled—in recent works by Johns, specifically *Mirror's Edge* (1992; fig. 1) and *Mirror's Edge 2* (1993; fig. 2). The mirror itself is a reversible and rotating object inasmuch as it creates a fundamental uncertainty between left and right—and, in these paintings, between top and bottom. Moreover, the mirror raises in a specific way the issue of the boundaries between the visible world and the body, while its edge, which in these two paintings becomes a vast surface that merges with the actual mirror, presents itself as a place of memory where one can insert and store souvenirs in the form of objects as well as images. Redefined and reworked by Johns, these ideas cease to be truly academic and together raise a single and crucial problem: that of a specific conception of the pictorial surface and its unity. By offering to take apart what is interlaced and to disentangle what is tangled, this essay aims not to destroy the unity, but to understand it.

The Principle of Rotation

Johns has said that the idea of a rotating point of view was introduced to him as a principle of Cubist origin.[2] As a result, he challenges the laws of perspective and introduces a plurality of viewpoints into his definition of the image. It is no accident that *Mirror's Edge* incorporates a jumbled version of its own title along the bottom edge, which gives the impression that it is an insertion that can only be read if inverted. But it is only an illusion, since the specular inversion is in this case neither total nor defining. Instead, the script intertwines backwards and forwards, thereby pointing out to the reader/spectator the necessity of deciphering and the unavoidability of decoding. In *Mirror's Edge 2,* the (pseudo)specular title of the first painting is absent and, perhaps more importantly, the canvas is inverted. The right/left relationship remains problematic. The wooden frame, which defines the painting as a mirror edge, is now on the right, whereas in the earlier painting it was on the left. Here we also find, between the painted frame and the invisible surface of an illusory mirror, two cards bearing the painter's initials—a common addition to traditional trompe l'oeils. These are accompanied by the date of the canvas. The presence of the signature and date replaces (or completes) the title, which is present only in *Mirror's Edge*. All this could lead us to believe that we might gain profound

1 See Dorothy C. Miller, ed., *Sixteen American Artists*, exh. cat. (New York: Museum of Modern Art, 1959), 22.

2 Ibid. Johns wrote that this idea was proposed by "a teacher of mine (speaking of Cézanne and cubism)."

fig. 1

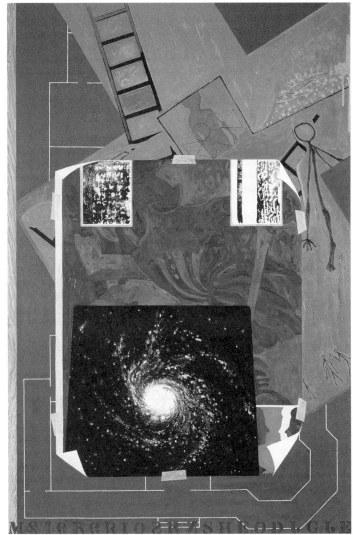

fig. 2

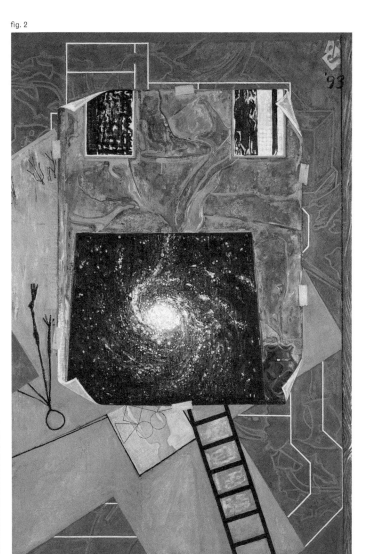

fig. 1 Jasper Johns, *Mirror's Edge*, 1992, oil on canvas,
66 x 44 in. (167.64 x 111.76 cm), Private collection, Switzerland

fig. 2 Jasper Johns, *Mirror's Edge 2*, 1993, encaustic on
canvas, 66 x 44⅛ in. (167.64 x 112.08 cm), Collection Robert
and Jane Meyerhoff, Phoenix, Maryland

fig. 3

fig. 3 Jasper Johns, *The Seasons*, 1990 (cat. no. 30; p. 76)

understanding only by looking at the canvases as though they were two parts of a diptych.

If the artist's intention was to form a diptych, this is manifested in all its complexity in the top/bottom relationship, but here, too, the inversion is only partial. In the second painting—which gathers the strata of a personal imagination in a mixture of baroque trompe l'oeil and cubist collage—one can pick out certain obsessive motifs and quotations from several of the artist's previous works. Only one of these elements is truly inverted in the two paintings: a detail from the etching *The Seasons* (1990; fig. 3), which simply repeats and rearranges key motifs from the series of color intaglio prints created by Johns in 1987 (cat. nos.14–17; pp. 62–65). In *Mirror's Edge 2*, two elements instantly stand out to indicate the inversion: the ladder, which is now bottom right, and the childish rendering of an upside-down *Kopffüssler*.[3] The latter does not appear in *The Seasons* etching and could be considered at the very most as an extrapolation and/or enlargement of one of the spindly figures in that work. Comparing this *Kopffüssler* to its twin figure in *Mirror's Edge*, it becomes apparent that, in its "fall," its pose has changed slightly. There are, however, other image-objects in which any changes are more ambiguous. Of these, the most significant is undoubtedly that of the central nebula, which thematically presents rotation, so to speak, as the cosmic principle at the very heart of the canvas. A photograph brought in as a trompe l'oeil, this element does not appear to change considerably from one painting to the other (notice that the same

3 *Kopffüssler* is a term used in the study of the psychology of form that refers to a child's drawing of a human figure with a head and limbs, but no torso. In German, *Kopf* means "head" and *Füsse* means "feet" or "legs."

corner of the paper is turned up and the same piece of tape is depicted in both paintings). The nebula itself is identical yet different; it is only inside the representation—where the star dust becomes finer and more diffuse over time—that the change takes place.

One of the main difficulties in interpreting Johns' work is the plurality of registers upon which he constructs his images. This is very much the case with the *Mirror's Edge* paintings. The nebula, for example, harks back to Gestalt psychology, which Johns studied in his youth. In one book, which according to commentators[4] was especially valued by the artist—Richard Gregory's *The Intelligent Eye*[5]—the nebula known by the name of its discoverer, Herschel, and also referred to by the acronym M51, is reproduced three times: first as a nineteenth-century drawing; then as a twentieth-century drawing; and finally as a photograph. The primary aim of these three reproductions in the text is to illustrate the possible translation of the same truth into optically different forms. Furthermore, they are seen as forms symbolic of dynamic expansion, given concrete expression by the diagram at the end of the book (fig. 4). Johns calls upon the same principle, even though he does not reproduce exactly the same representation (fig. 5).[6] However, it is crucial to avoid oversimplifying the way Johns operates. It is not just Gestalt psychology at work in *Mirror's Edge*, but a whole pictorial tradition of which the names Vincent van Gogh and Edvard Munch are an integral part. But by evoking these names, as the reader will already have realized, we are clearly going beyond the Gestaltist problematic of the principle of rotation by opening a second dossier: that of transfer and combinatory mnemonics.

The Art of Memory

That Johns has a phenomenal visual memory is unquestionable. This fact has already prompted some important studies[7] in which the point of departure is usually the following key assertion made by the artist on the subject:

> Seeing a thing can sometimes trigger the mind to make another thing. In some instances the new work may include, as a sort of subject matter, references to the thing that was seen. And, because works of painting tend to share many aspects, working itself may initiate memories of other works. Naming or painting these ghosts sometimes seems a way to stop their nagging.[8]

At this point, we could comment on the way Johns confronts Munch, Van Gogh, himself, and the stars. But we shall not, for the simple reason that there is, it seems to me, more interesting food for thought in the two *Mirror's Edge* paintings: both strike us as being genuine mise-en-scènes of an ancient art of memory. To the observant eye, Johns' experimentation with the theme of memory is in evidence throughout his work. He goes beyond the Duchampian notion of the *memory imprint* to revisit deep roots that stretch as far back as the mnemonic systems

fig. 4

fig. 5

fig. 4 If a larger version of this spiral were spinning clockwise, it would appear to expand. If the motion ceased after a few seconds of viewing, the spiral would seem to shrink. The effect, however, is paradoxical, because just as the spiral looks like it decreases in size, it also appears to remain the same. This consequence of movement can be transferred to other objects. (A version of this text accompanied the illustration in its original publication, Richard Gregory's *The Intelligent Eye* [1970].)

fig. 5 Jasper Johns, *Mirror's Edge 2*, 1992 (detail from fig. 2)

4 Roberta Bernstein, "Seeing a Thing Can Sometimes Trigger the Mind to Make Another Thing," in Kirk Varnedoe, *Jasper Johns: A Retrospective*, exh. cat. (New York: Museum of Modern Art, 1996), 49 and 71, n. 55.

5 Richard Gregory, *The Intelligent Eye* (New York: McGraw-Hill, 1970).

6 Ibid. Other elements discussed by Gregory, such as primitive silhouettes and "Rubin's vase," recur in Johns' work.

7 See especially Bernstein, "Seeing a Thing."

8 Ibid., 39.

fig. 6

fig. 7

fig. 6 Illustration from Robert Fludd, *Utriusque cosmi maioris scilicet et minoris metaphysica, physica atque technica historia*, vol. II (Oppenheim, 1619)

fig. 7 Illustration from Ramón Llull and Thomas le Myésier, *Electoruim Parvum seu Breviculum*, cod. St. Peter perg., 92, fourteenth century

of the Jewish Kabbalah and *ars inveniendi et memorandi* of the ancient philosophers. How much of this deep reclamation work is the result of the artist's specific intention and how much is the consequence of the innate strength of his work—which, in many instances, can transcend the artist himself—remains an open question. In the absence of the detailed study it deserves, the following observations may provide a few pointers.

Now-classic studies have demonstrated the importance of the graphic construction of cumulative images in the search to systemize universal knowledge, the key to which the Kabbalah and *ars memorativa* sought to discover (and keep).[9] It is striking how in his experimentation—which, it must be stressed, is an artistic experimentation with personal and universal memory—Johns retraces some of these journeys.

So as not to stray too far from our point of departure, we need only reconsider *Mirror's Edge* and *Mirror's Edge 2* from this perspective to discover the survival of an ancient cognitive symbolism. In the most important book of the Elizabethan period to come out of the tradition of the Jewish Kabbalah, the *Utriusque cosmi* (1619; fig. 6),[10] both the structure of the universe and that of human understanding are visualized as ascending, stepped formulations. It is essential, however, to look beyond the remarkable similarity between some of Robert Fludd's diagrams and some of Johns' works and ask ourselves why—in the case of *Mirror's Edge*—does the similarity exist solely in the later canvas? For it is in *Mirror's Edge 2* that the relationship between Johns' images of the ladder and the nebula can, in every respect, be compared to that of the ladder and the firmament in Fludd's diagrams. In Johns' work, the ladder derives from his 1985–1986 cycle of *The Seasons* paintings (and, therefore, from still further back in time), while the nebula is drawn from theses on psychology of form and, in my view, from images of the night sky by Van Gogh and Munch. In a parallel way, Fludd's images of the ladder, which originate from Ramón Llull (fig. 7), illustrate the ascension of knowledge. Unable to offer a definitive response to the question posed above, and reluctant to try, I shall limit myself to noting two facts. The first is that, even in ancient kabbalistic iconography, there were already indications of a double path, from the top downward and from the bottom upward. In Fludd's illustration, this double path is suggested by the inverted projection of the ladder, drawn in dotted lines, and in Llull by the illustration of the "fall of vices" theme, which also emerges, mutatis mutandis, in Johns. The second and, in my opinion, far more crucial fact is the realization that only by inverting a primary mnemonic system, which we shall call "profane," can we reclaim the valences of an ancient knowledge, which we shall call "sacred."

The Boundary of the Body

Mirror's Edge and *Mirror's Edge 2*, painted in 1992 and 1993 respectively, produce a *mise-en-abyme* with the 1990 etching *The Seasons*, which then presents itself as a summary of the

9 See Paolo Rossi, *Clavis universalis: Arti della memoria e logica combinatoria da Lullo a Leibniz* (Milan/Naples: Ricciardi, 1960); Paolo Rossi, *Logic and the Art of Memory*, Stephen Clucas, trans. (Chicago: Athlone, 2000); Frances A. Yates, *The Art of Memory* (Chicago/London: University of Chicago Press, 1966); Gershom Scholem, *On the Kabbalah and Its Symbolism* (New York: Schocken Books, 1965).

10 Robert Fludd, *Utriusque cosmi maioris scilicet et minoris metaphysica, physica atque technica historia* (Oppenheim, 1619). For more on the context, see William H. Huffman, *Robert Fludd and the End of the Renaissance* (London/New York: Routledge, 1988).

cycle of four prints produced in 1987. The
principle of rotation is at work in the vertigi-
nous interlocking of forms; this rotation is
directly related to the reemergence of the
ancient art of memory. When one considers
the genesis of the 1985–1986 cycle of *The
Seasons* paintings, which has been well-
documented and studied,[11] one is struck by
the openness of the sequential relationship
of the four pieces. The canvas dedicated to
Summer was, we know, the first to have
been produced, though in later variations it
was relegated to second place in a logical
and chronological sequence that starts with
Spring and ends with *Winter*. But this is not
always the case. In related drawings that
Johns created after beginning the cycle of
paintings, sometimes summer is in first
place, sometimes winter, and sometimes
spring (figs. 8–10). These permutations give
us access to the artist's thoughts on time,
thoughts that endow the human presence
with its proper role in the cycle of time. Johns
knows that there is no time outside the
"consciousness of time," and in *The Seasons*
this is brought to light by the huge cast
shadow that overruns the representation.
But, as he is also fully aware, there is neither
consciousness nor time outside man's body.
The body exists in time, and therefore, like
the seasons, it changes and passes. And yet
Johns' shadow is somewhat immutable
despite its repetition. What is the significance
of this oscillation? What is the secret of the
to-ing and fro-ing between "permanence"
and "passage" revealed to us by the shadow
projected onto the screen of the seasons?
Moreover, to whom does this shadow
belong? The artist? The spectator? Both?

fig. 8

fig. 9

fig. 10

fig. 8 Jasper Johns, *The Seasons*, 1989, ink on plastic,
26 x 58 in. (66 x 147 cm), Collection the artist

fig. 9 Jasper Johns, *The Seasons*, 1989 (cat. no. 24; p. 75)

fig. 10 Jasper Johns, *The Seasons*, 1989, ink on plastic,
20 ¼ x 52 in. (51.44 x 132.08 cm), Collection the artist

11 *Jasper Johns: The Seasons* (New York: Leo Castelli Gallery,
1987), text by Judith Goldman; Roberta Bernstein, *Jasper
Johns: The Seasons* (New York: Rizzoli, 1992); Barbara
Bertozzi, *The Seasons: Jasper Johns* (Milan: Charta, 1996).

fig. 11

fig. 12

fig. 11 Jasper Johns photographed by Mark Lancaster in Stony Point, New York, working on *Untitled*, 1984

fig. 12 Illustration from Karl Ludwig, Elector Palatine, and Paulus Hachenberg, *Philothei Symbola Christiana: quibus idea hominis Christiani exprimitur* (Frankfurt, 1677)

One of the shots in a very beautiful cycle of photographs taken by Mark Lancaster (fig. 11) a year before the birth of *The Seasons* actually exposes the way the artist's presence *in* his own work becomes visible through the projection of his shadow onto the canvas. It is the actual experience of the act of creation, its temporality, that is significant here. The moment of contact between the hand and the canvas is fleeting, but it produces a form—the result of the intertwining of passage and permanence. Once again, Johns' imagination (and here, too, that of Lancaster) is legible on at least these two registers: historical memory and personal memory.

The artist has no power over historical memory; on the contrary, the artist is in its power. It is therefore pointless to speculate as to whether Johns or Lancaster had either firsthand knowledge or a real understanding of the ancient symbolic mise-en-scènes devoted to the relationship between time and eternity (fig. 12). Far more important is their ability to re-create them, and therefore it is not the "repetition" so much as the "difference" that is significant.[12] Now this difference, the "Johns" difference, is produced by countless recurrences and countless differences. Some—such as his debt, in *The Seasons*, to Picasso's *The Shadow*—have time and again been pointed out by commentators (fig. 13).[13] But once again, going a step further can prove most enlightening. Picasso's idea of "entering" his paintings through a shadow projection has an important precedent in the work of Munch.[14] But in Picasso's work, the shadow is highly sexualized,[15] a fact that has not escaped Johns. If he repeats the shadow, it is to re-endow it with some of the cosmic power with which Munch had previously invested it.

12 An allusion to Gilles Deleuze, *Différence et Répétition* (Paris: Presses universitaires de France, 1968).

13 See studies cited in note 12 and Jill Johnston, "Tracking the Shadow," *Art in America* 75, no. 10 (October 1987): 129–142.

14 On this subject, see Louise Lippincott, *Edvard Munch: Starry Night* (Malibu, California: J. Paul Getty Museum, 1988).

15 See Victor I. Stoichita, *A Short History of the Shadow*, Anne-Marie Glasheen, trans. (London: Reaktion Books, 1997), 120.

fig. 13

fig. 14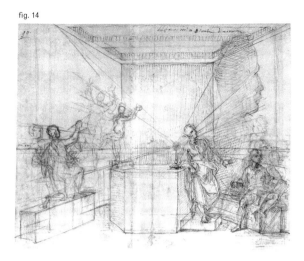

The time has come to turn to the third academic idea referred to by Johns: "the boundary of a body is neither a part of the enclosed body nor a part of the surrounding atmosphere." This concept, which comes from Leonardo, alluded above all to the notion of sfumato, the blurred contour of which the Italian painter was the undisputed master. Leonardo and his students experimented with shadow projections that both dilated and erased the overly rigid boundaries of figures (fig. 14).[16] Once again, Johns expands on this idea in his own way, and what interests him is the problematic of the body in the work, the work-body. In regard to personal memory, this too was old experimentation. The first significant results had been obtained by the artist in the 1960s and 1970s in the most direct and most autobiographical way possible: imprints of the body onto the support (fig. 15).[17] Before incorporating (or before being) the artist's shadow, the work, as it were, incorporates (is) his skin. The titles of the ensuing pieces—*Skin*—are undoubtedly central. Not "imprint," not "projection," just, significantly, "skin"—as though, during the artistic process, the projection had become a thing, as though the surface of the work and the surface of the body had become one.[18] A comparison with the established iconography of the skin (fig. 16) confirms Johns' ability to actualize apparently lost or forgotten ancient motifs, while the personal significance of his approach marks it as unquestionably contemporary.

In his book *Jasper Johns* (1984), Richard Francis has given us a description of the artist "covering himself with oil and pressing against a sheet of drafting paper, which was then dusted and rubbed slightly with powdered graphite."[19] This account thematizes the importance of the materials (oil, pigment, paper) in the transition from surface of the body to surface of the work, but it needs to be corroborated by additional visual evidence. There are several interesting details in the series of photographs taken by Ugo Mulas in 1965 (Shiff, fig. 12, p. 25), although

fig. 13 Pablo Picasso, *The Shadow*, 1953, oil, charcoal on canvas, 51 x 38 in. (129.5 x 96.5 cm), Collection Musée Picasso, Paris

fig. 14 Anonymous, after Leonardo da Vinci, illustration from Carlo Urbini, *Codex Huygens*, sixteenth century, MA 1139 (f. 90), Collection the Pierpont Morgan Library, New York

16 See Thomas DaCosta Kaufmann, "The Perspective of Shadows: The History of the Theory of Shadow Projection," *Journal of the Warburg and Courtauld Institutes* XXXVIII (1979): 267–275.

17 Details in Roberta Bernstein, "Jasper Johns and the Figure: Part One, Body Imprints," *Arts Magazine* 52, no. 2 (October 1977): 142–143; Nan Rosenthal, et al., *The Drawings of Jasper Johns*, exh. cat. (Washington, D.C.: National Gallery of Art, and New York: Thames & Hudson, 1990), 170–173; and Varnedoe, *Jasper Johns: A Retrospective*, 29–33. For the whole problematic of the imprint in modern and contemporary art, consult Georges Didi-Huberman, *L'Empreinte* (Paris: Centre Georges Pompidou, 1997).

18 Prominent among the studies on the cultural symbolization of the skin are: Didier Anzieu, *The Skin Ego* (New Haven/London:

Yale University Press, 1989); and Claudia Benthien, *Haut Literaturgeschichte, Koerperbilder, Grenzdiskurse* (Reinbeck bei Hamburg: Rowohlt, 1999).

19 Richard Francis, *Jasper Johns* (New York: Abbeville Press, 1984), 54.

fig. 15

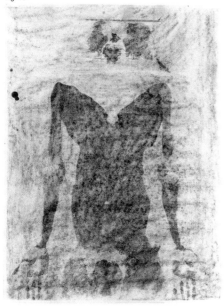

fig. 16

fig. 17

fig. 18

attention will be drawn only to those thought to be of significance here. The first is without question the nature of the series itself, for it is in the unfolding in time, in the almost crazy effort "to pass" that the full significance of the metamorphosis of "Jasper Johns" into a "skin/work" can be seen. Another notable detail is the unusually eloquent role played by the cast shadow, which establishes a kind of intermediate stage in the passage from "Johns" to *Skin*. Virtually absent at the beginning of the story, the shadow grows in importance and eventually blossoms in the line of images that immediately precedes the reification of the skin.

The shadow as a symbol of identity is a wonderful motif in the Western imagination. The most famous example is to be found in Adelbert von Chamisso's *The History of Peter Schlemihl* (1836), the man who lost his shadow (fig. 17). In its absence, Schlemihl no longer has a clear identity, a soul, or a body. He is, literally, *no-body*.[20] Johns prefers to take the opposite path. He does not actually separate himself from his shadow; he transforms it into a work, and the latter becomes the symbol of his identity. If we search for an iconography of reified skin, we can find it in different forms and contexts (fig. 18),[21] but I know of no story that has as its hero a man who has lost his skin, not even for the sake of his art. Maybe Jasper Johns' is one such story.

Dr. Victor I. Stoichita is a professor of modern and contemporary art history at the University of Fribourg, Switzerland. His scholarly interests range from Andy Warhol to seventeenth-century Spanish masters such as Francisco de Zurbarán and Diego Velázquez. He has authored several books, including *Visionary Experience in the Golden Age of Spanish Art* (1995) and *A Short History of the Shadow* (1997), and coauthored *Goya: The Last Carnival* (1999) with Anna Maria Coderch.

fig. 15 Jasper Johns, *Skin*, 1975, charcoal, oil on paper, 41¾ x 30¾ in. (106 x 78.1 cm), Collection Richard Serra and Clara Weyergraf-Serra

fig. 16 Frontispiece from Thomas Bartholin, *Anatomia Reformata* (Leyden, 1651)

fig. 17 Adolf Schrödter, *The Man in Grey Seizes Peter Schlemihl's Shadow*, illustration from Adelbert von Chamisso's *Peter Schlemihls wundersame Geschichte* (Leipzig, 1836)

fig. 18 Giulio Bonasone, *Anatomical Study*, circa 1565, illustration from Giulio Bonasone and Stefania Massari, *Giulio Bonasone* (Rome: Edizioni Quasar, 1983)

20 Stoichita, *A Short History*, 167–185.

21 See especially Varnedoe, *Jasper Johns: A Retrospective*, 30–33.

Plates

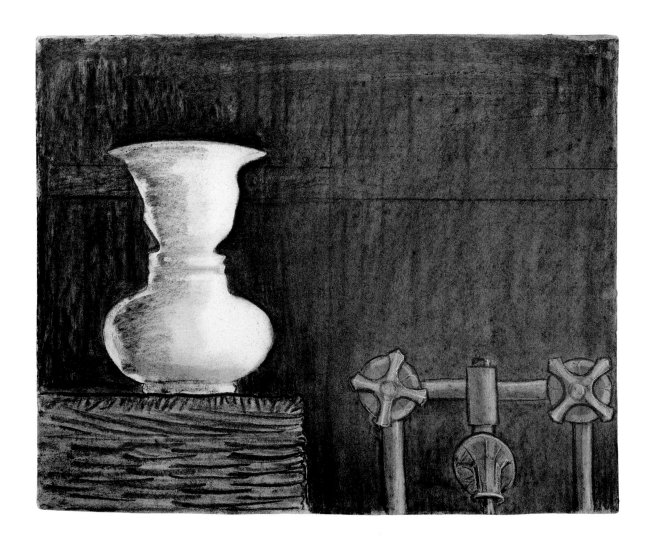

Untitled, 1983
charcoal, pastel on paper (cat. no. 1)

Ventriloquist, 1983
encaustic on canvas (cat. no. 2)

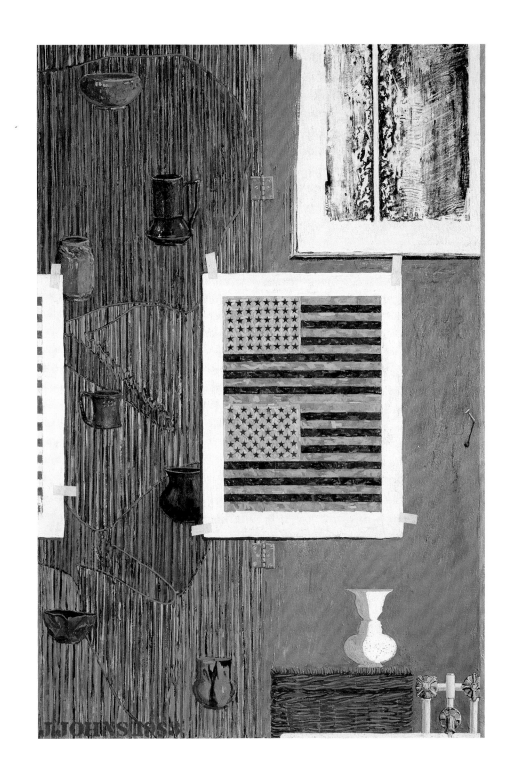

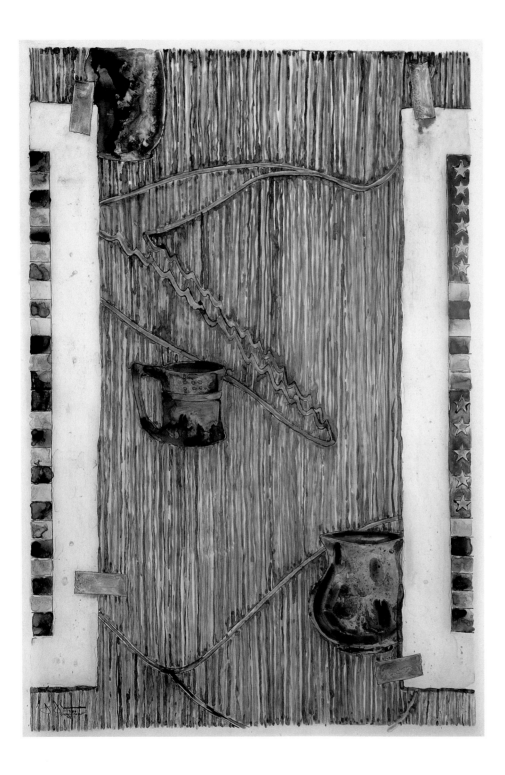

Ventriloquist, 1984
ink on plastic (cat. no. 3)

Ventriloquist, 1985
lithograph on paper (cat. no. 9)

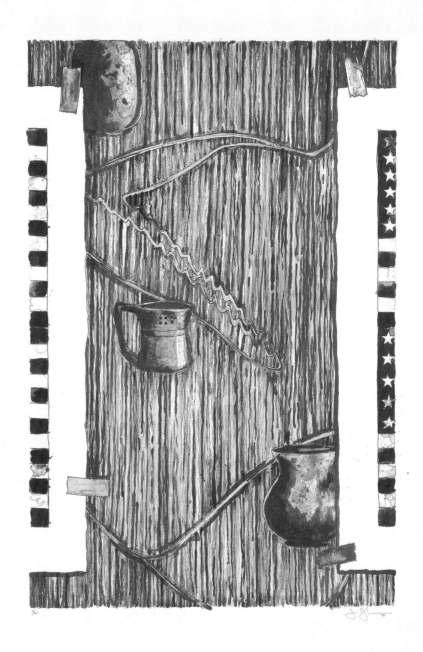

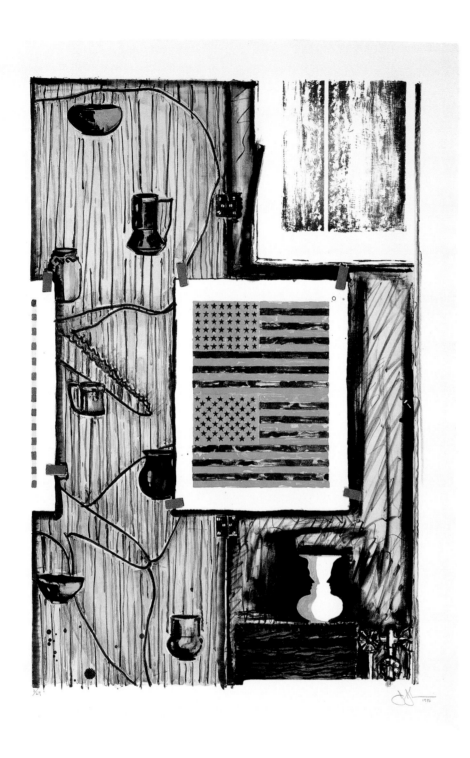

Ventriloquist, 1986
lithograph on paper (cat. no. 11)

Summer, 1985
intaglio on paper (cat. no. 7)

WALLACE STEVENS

POEMS

SELECTED AND WITH AN INTRODUCTION BY
HELEN VENDLER

THE ARION PRESS
SAN FRANCISCO
1985

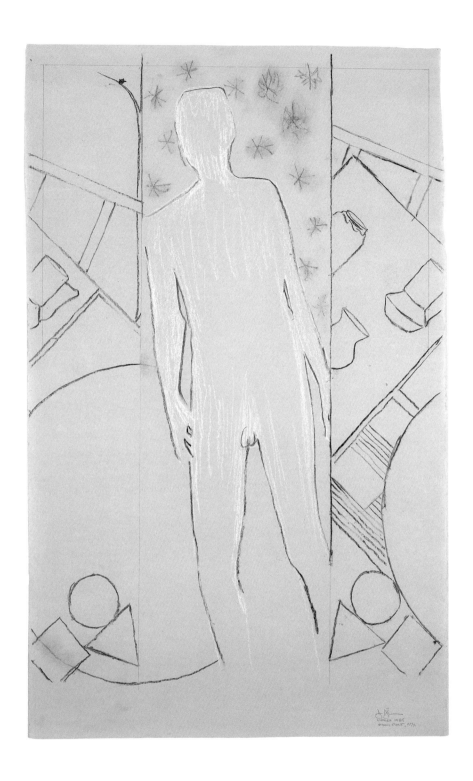

Summer, 1985
charcoal, chalk on paper (cat. no. 4)

Summer, 1985
charcoal on paper (cat. no. 5)

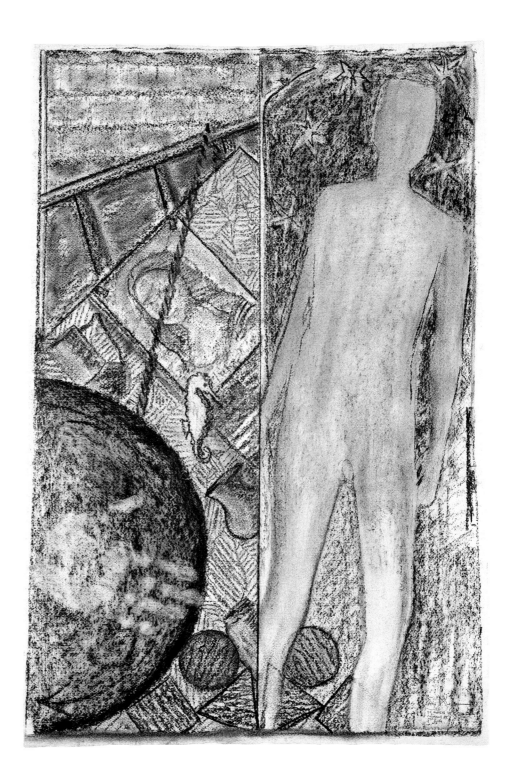

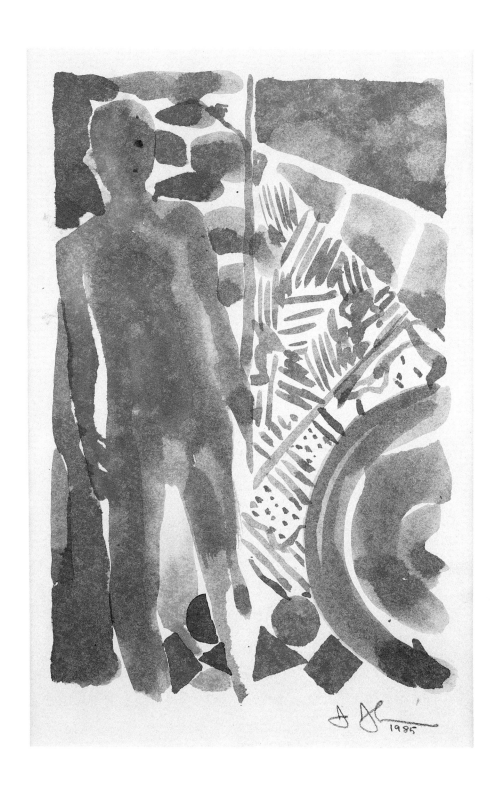

Summer, 1985
watercolor on paper (cat. no. 8)

Summer, 1985
graphite on paper (cat. no. 6)

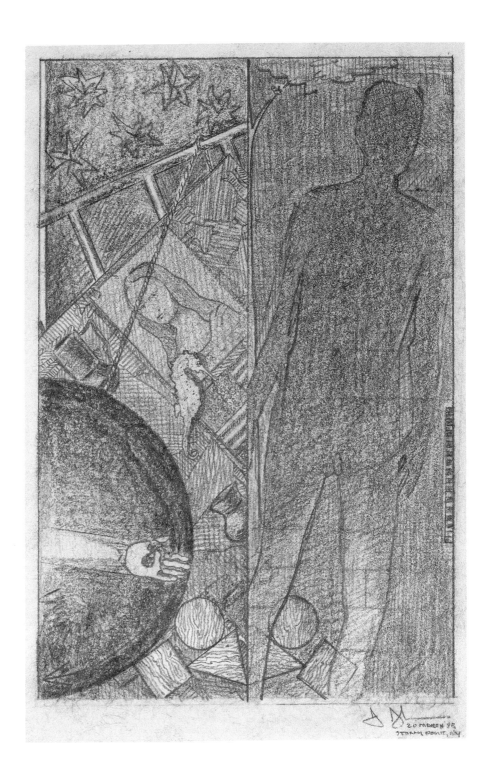

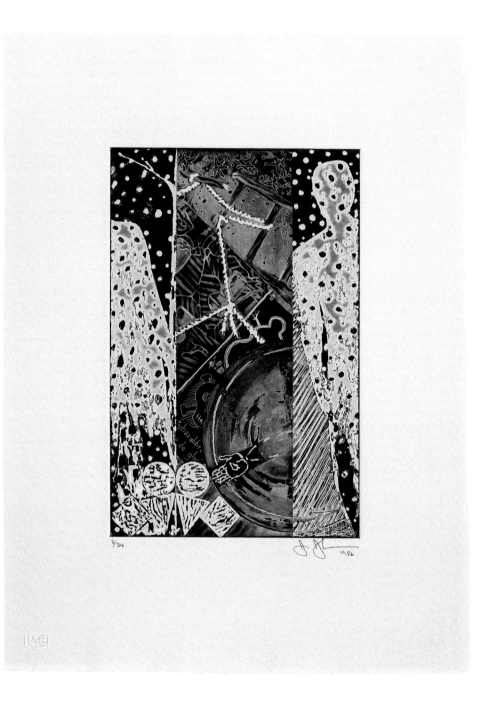

Winter, 1986
aquatint, etching, open-bite on paper (cat. no. 12)

Winter, 1986
encaustic on canvas (cat. no. 13)

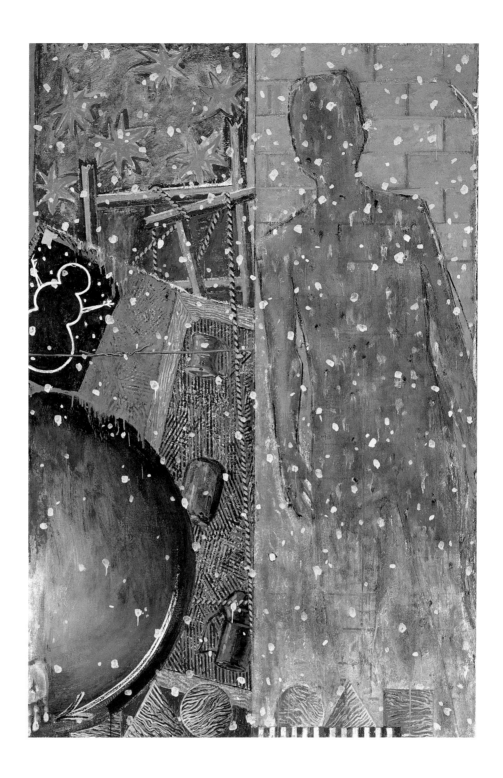

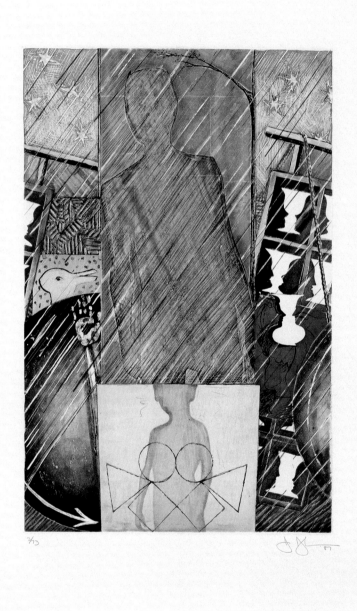

The Seasons (Spring), 1987
intaglio on paper (cat. no. 14)

The Seasons (Summer), 1987
intaglio on paper (cat. no. 15)

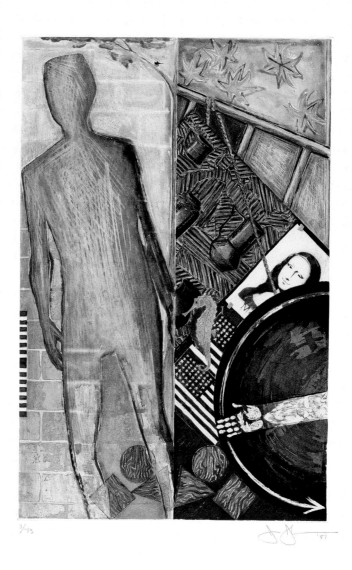

3/73 [signature] '87

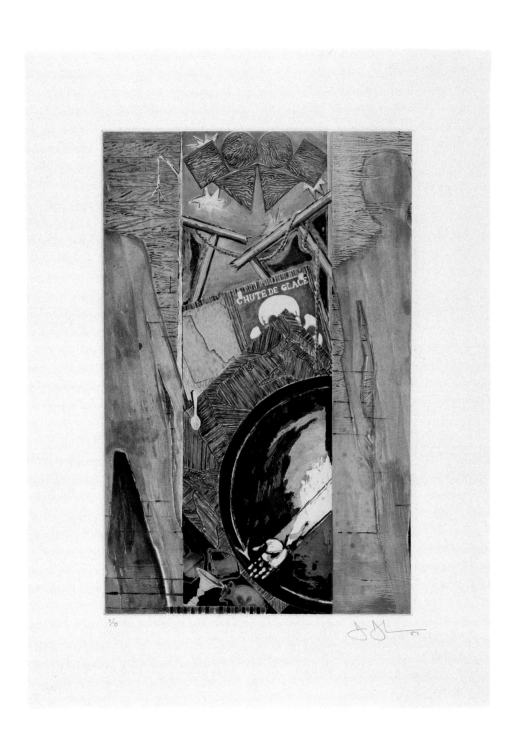

The Seasons (Fall), 1987
intaglio on paper (cat. no. 16)

The Seasons (Winter), 1987
intaglio on paper (cat. no. 17)

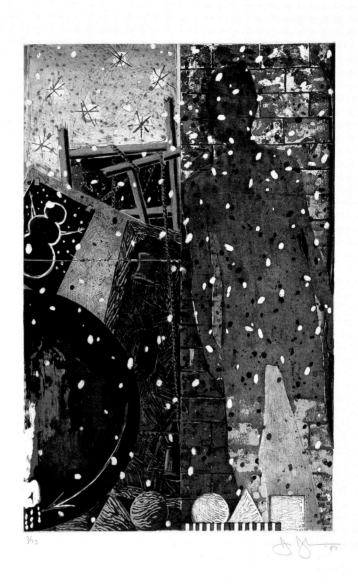

3/13

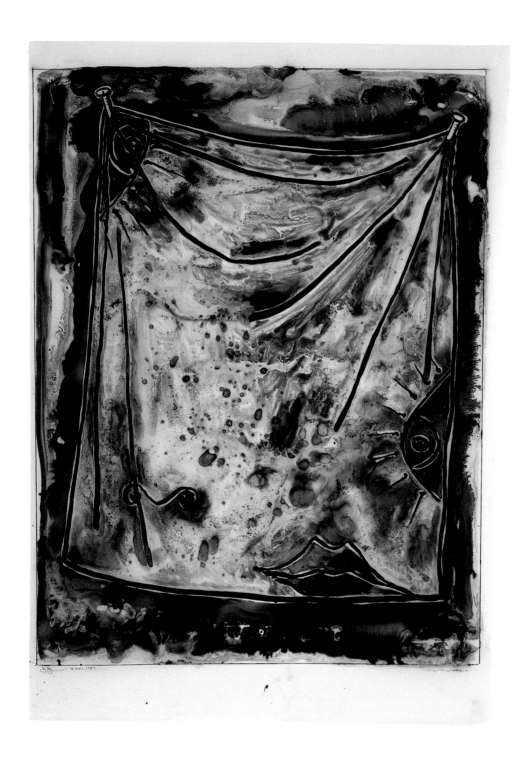

Untitled, 1987
ink on plastic (cat. no. 18)

Untitled, 1988
encaustic on canvas (cat. no. 21)

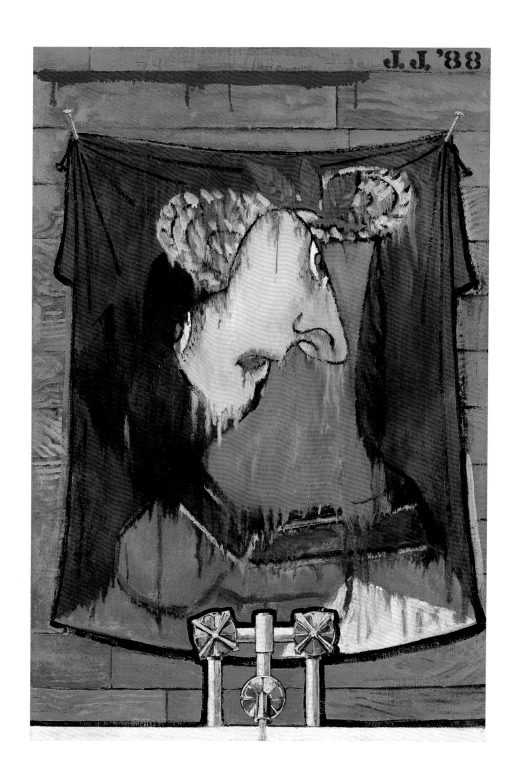

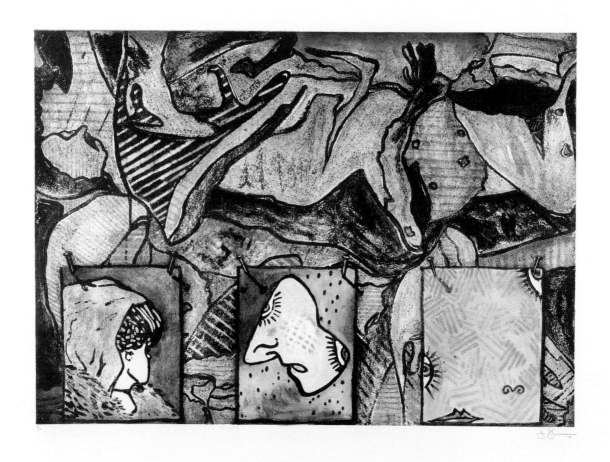

Untitled, 1988
carborundum print on paper (cat. no. 20)

Untitled, 1988
carborundum print on paper (cat. no. 19)

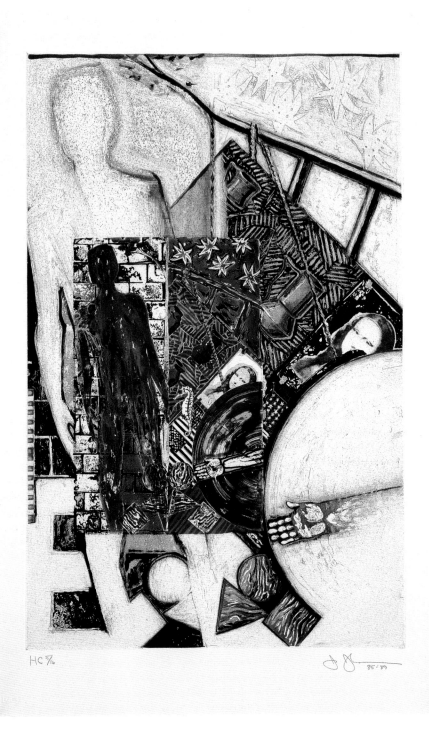

HC 5/16

85-89

Summer, 1989
intaglio on paper (cat. no. 22)

Winter, 1989
lithograph on paper (cat. no. 28)

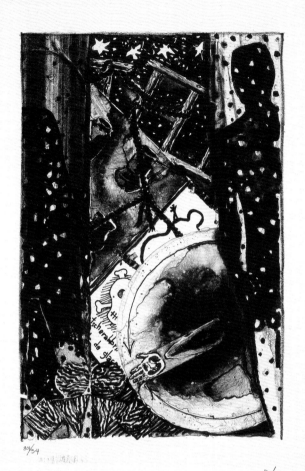

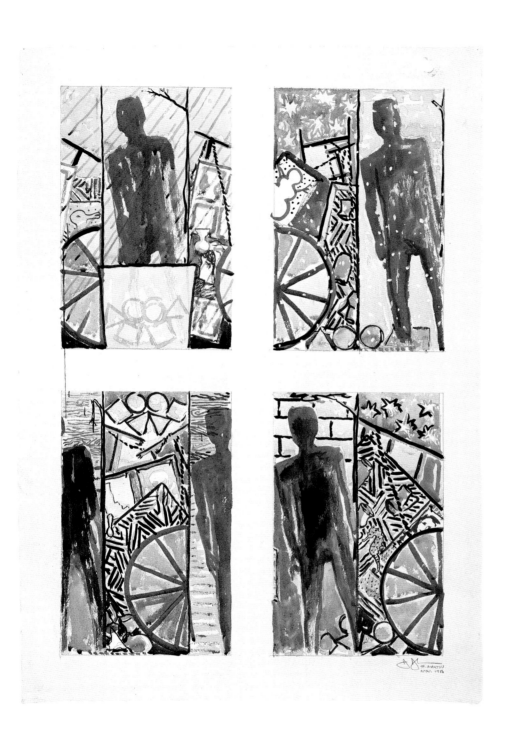

The Seasons, 1986
watercolor, ink on paper (cat. no. 10)

The Seasons, 1989
intaglio, chine collé on paper (cat. no. 25)

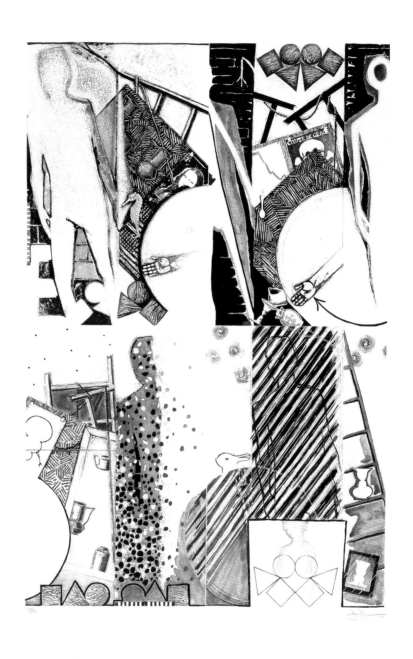

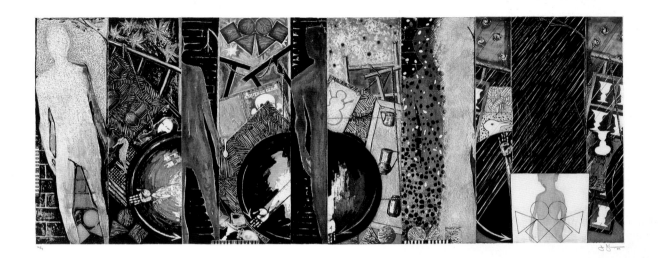

The Seasons, 1989
etching, aquatint on paper (cat. no. 23)

The Seasons, 1989
ink on plastic (cat. no. 24)

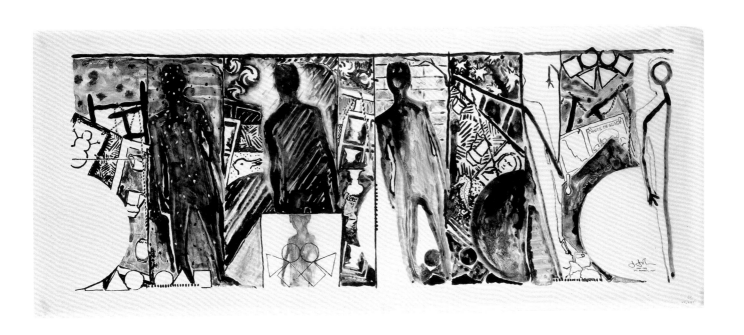

The Seasons, 1990
intaglio on paper (cat. no. 30)

Summer (Blue), 1991
lithograph on paper (cat. no. 39)

AP 3/9

Tracing, 1989
ink on plastic (cat. no. 26)

Tracing, 1989
ink on plastic (cat. no. 27)

TRACING FOR SARAH 8 JULY 1989 - JASPER

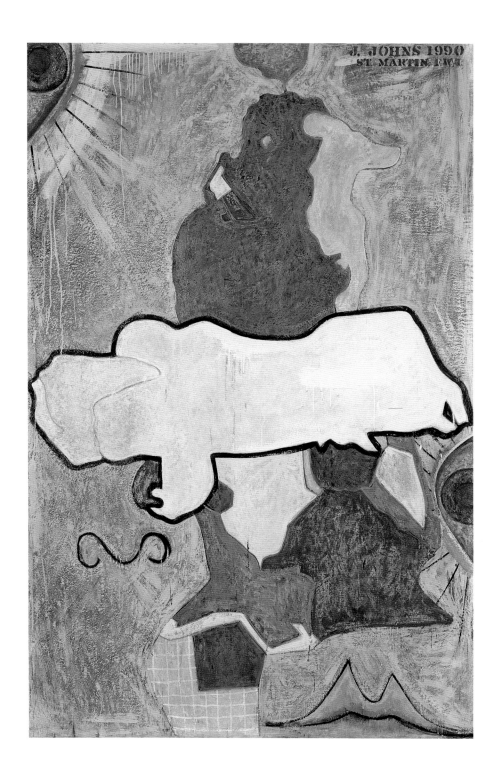

Green Angel, 1990
encaustic, sand on canvas (cat. no. 29)

Untitled, 1990
ink, watercolor, pencil on paper (cat. no. 31)

Untitled, 1990
pastel on paper (cat. no. 33)

Untitled, 1990
watercolor, charcoal, chalk, pencil on paper (cat. no. 34)

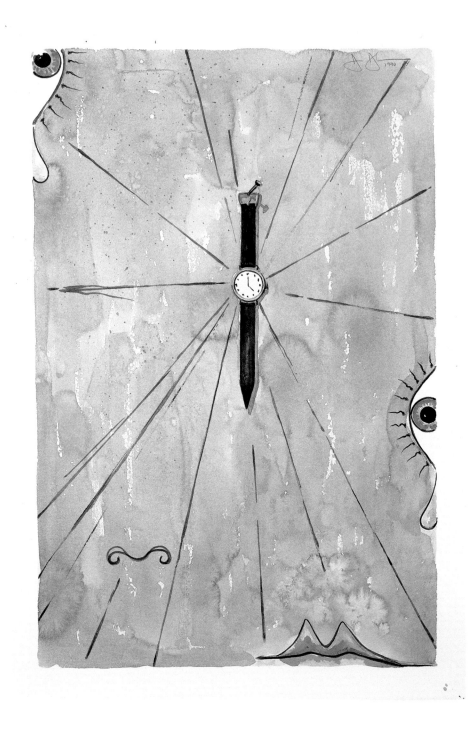

Untitled, 1990
watercolor, pencil on paper (cat. no. 35)

Untitled, 1990
watercolor, pencil on paper (cat. no. 36)

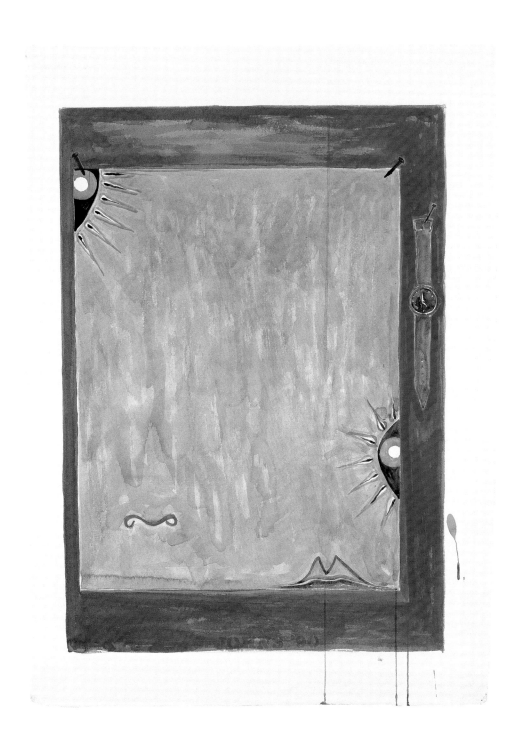

Untitled, 1990
lithograph on paper (cat. no. 32)

Untitled, 1991
encaustic on canvas (cat. no. 40)

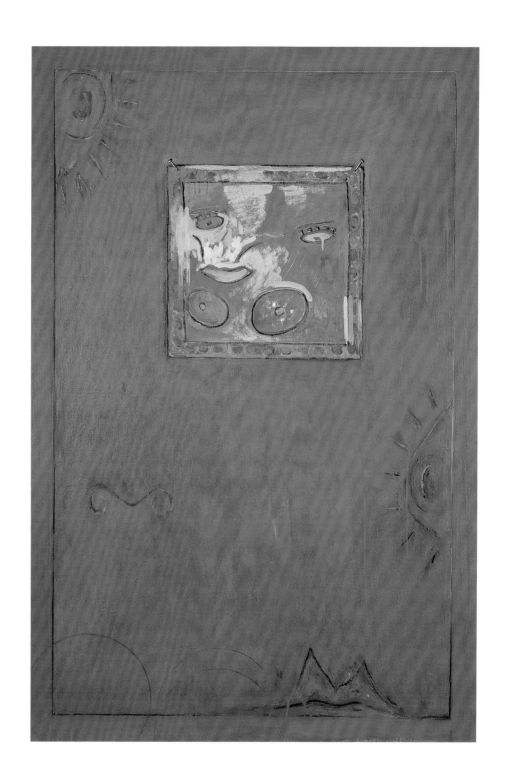

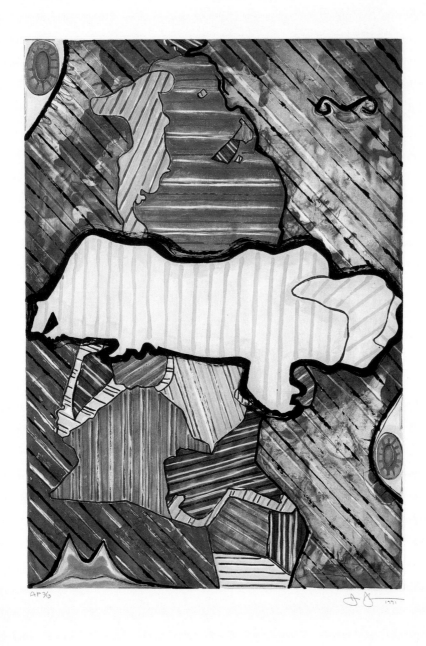

Green Angel, 1991
etching on paper (cat. no. 38)

Untitled, 1991
oil on canvas (cat. no. 42)

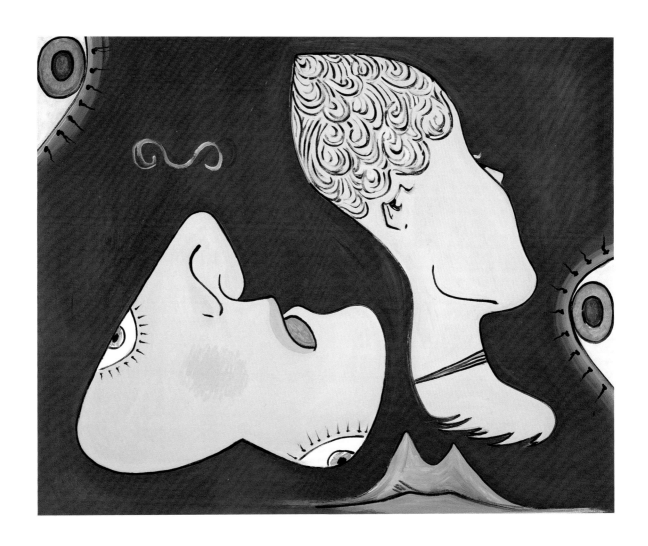

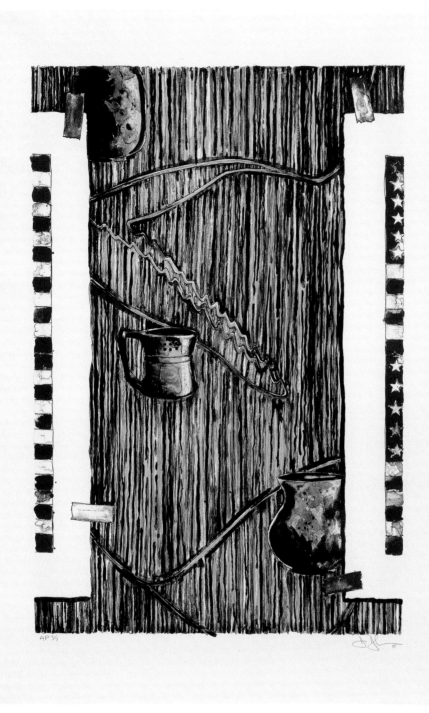

Ventriloquist, 1990
lithograph on paper (cat. no. 37)

Untitled, 1991
ink on plastic (cat. no. 41)

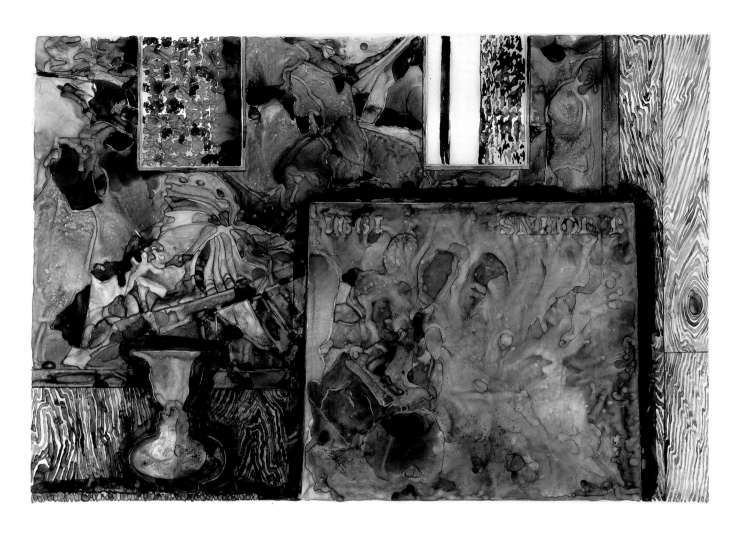

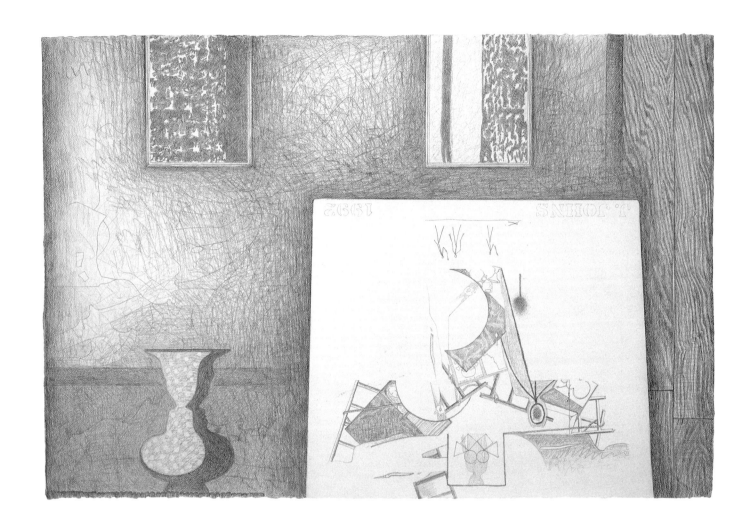

Untitled, 1992
graphite on paper (cat. no. 44)

Untitled, 1992
etching, aquatint on paper (cat. no. 43)

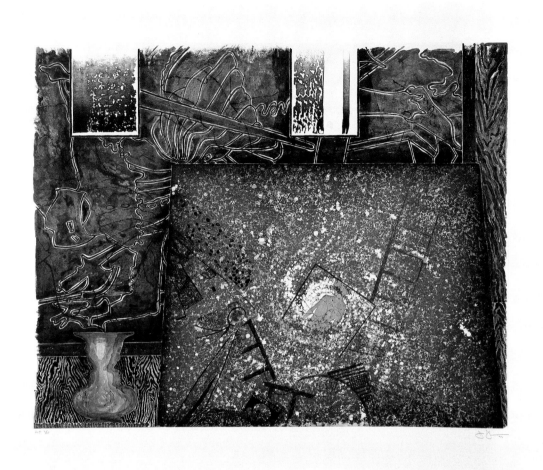

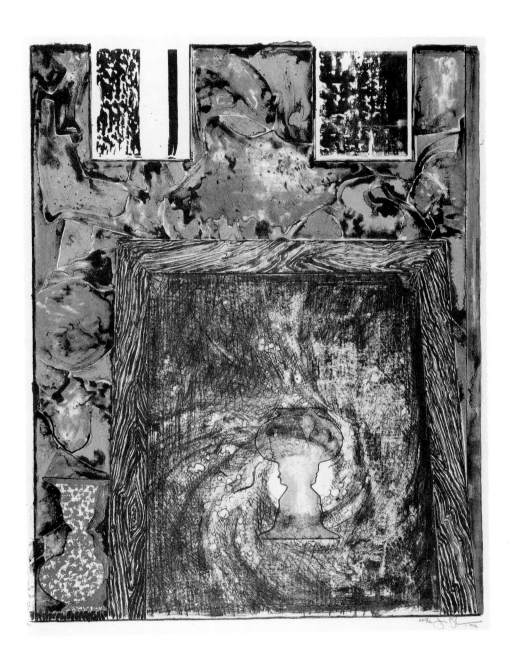

Untitled, 1992
lithograph on paper (cat. no. 45)

Untitled, 1992
lithograph on paper (cat. no. 46)

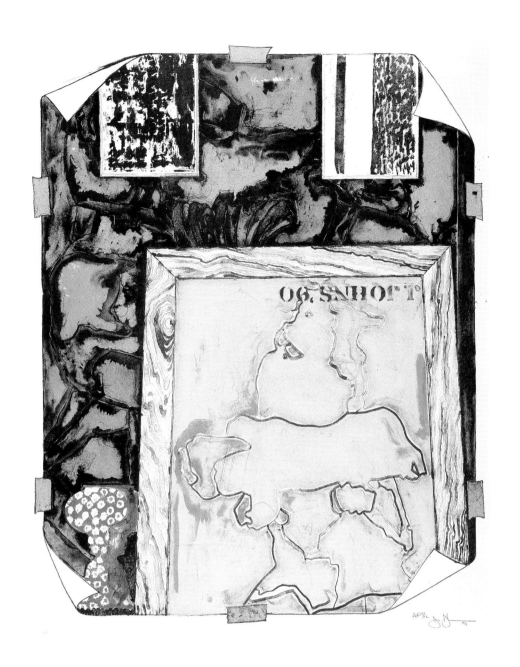

Untitled (after Holbein), 1993
pencil on paper (cat. no. 50)

After Holbein, 1993
lithograph on paper (cat. no. 47)

AP 3/4

97

After Holbein, 1993
lithograph on paper (cat. no. 48)

After Holbein, 1993
lithograph on paper (cat. no. 49)

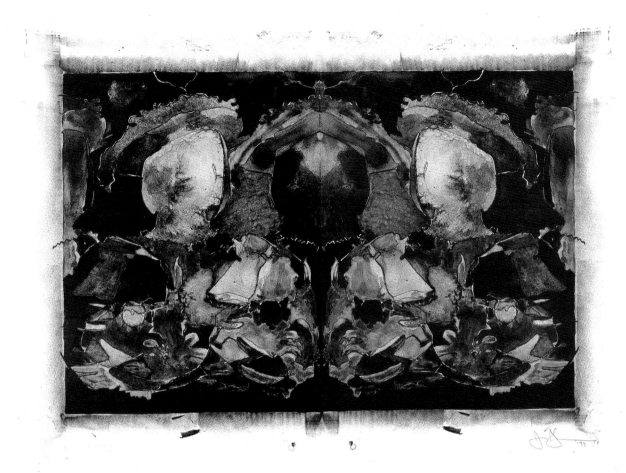

AP 3/40

After Holbein, 1994
lithograph on paper (cat. no. 51)

Untitled, 1994
lithograph on paper (cat. no. 52)

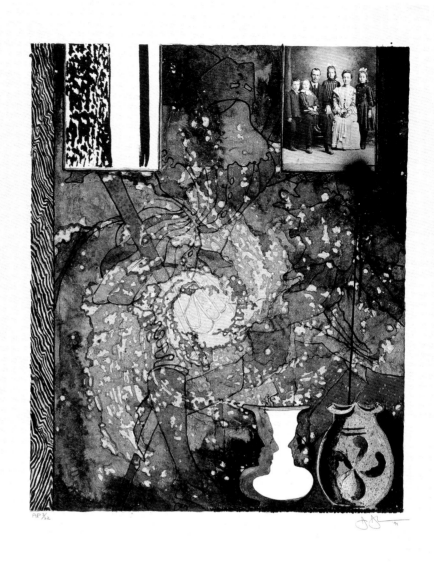

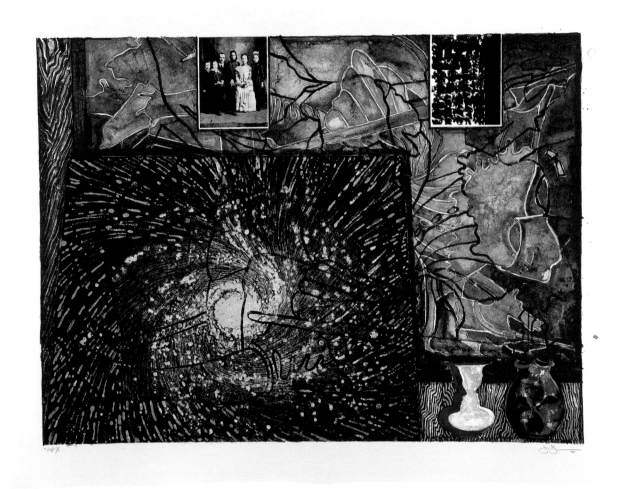

Untitled, 1995
lithograph on paper (cat. no. 54)

Untitled, 1994
pastel, charcoal on paper (cat. no. 53)

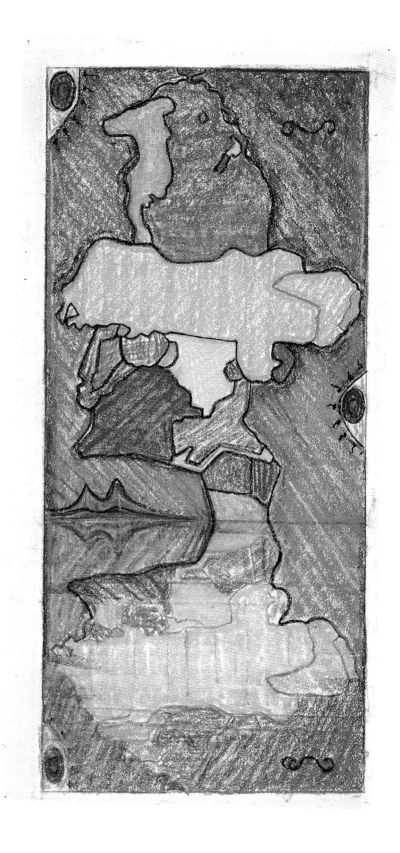

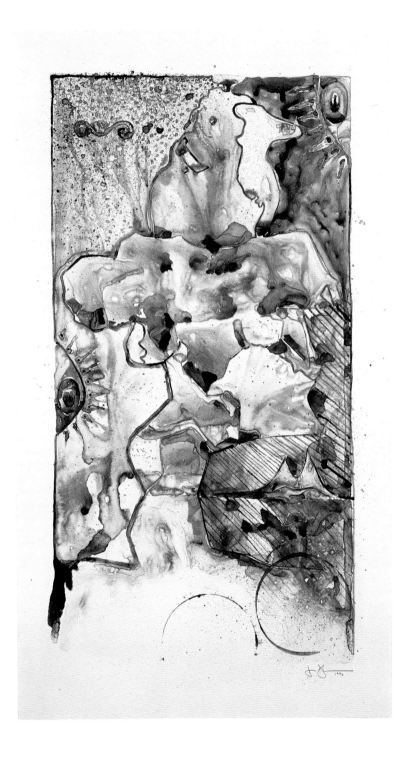

Untitled, 1996
monotype on paper (cat. no. 60)

Green Angel 2, 1997
intaglio on paper (cat. no. 61)

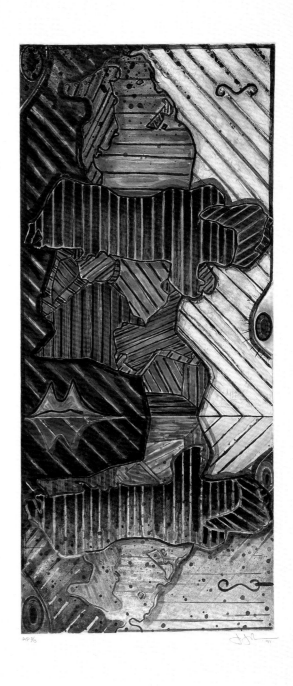

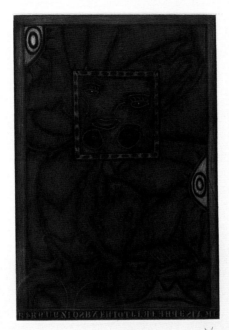

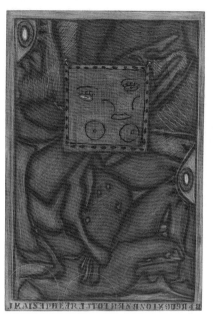

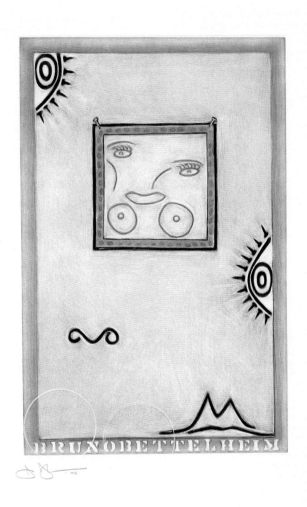

Untitled, 1995
mezzotint on paper (cat. no. 57)

Face with Watch, 1996
intaglio on paper (cat. no. 58)

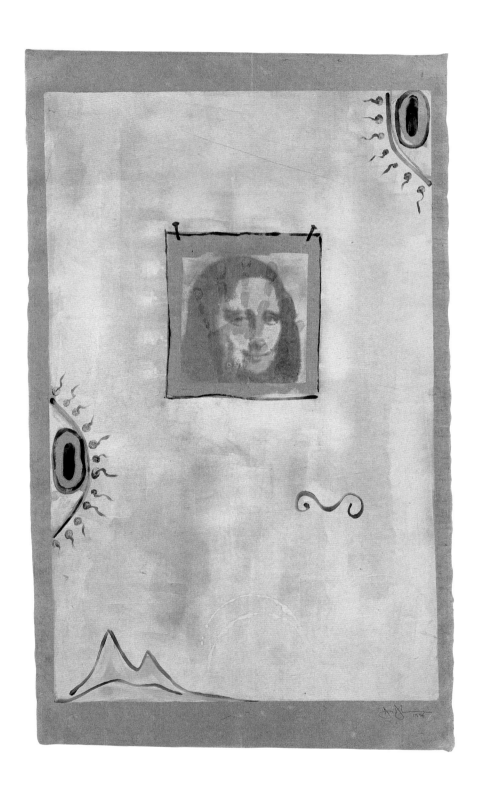

Untitled, 1996
monotype on paper (cat. no. 59)

Untitled, 1997
intaglio on paper (cat. no. 62)

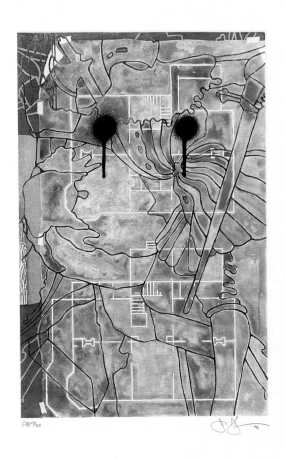

Untitled, 1998
etching on paper (cat. no. 64)

Untitled, 1999
intaglio on paper (cat. no. 68)

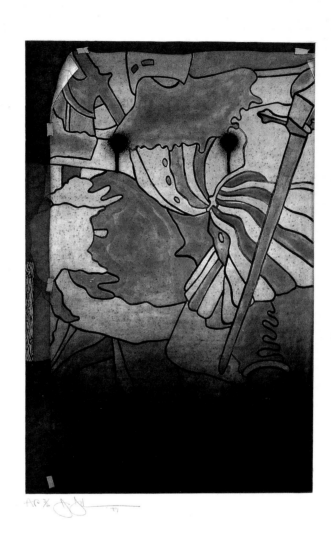

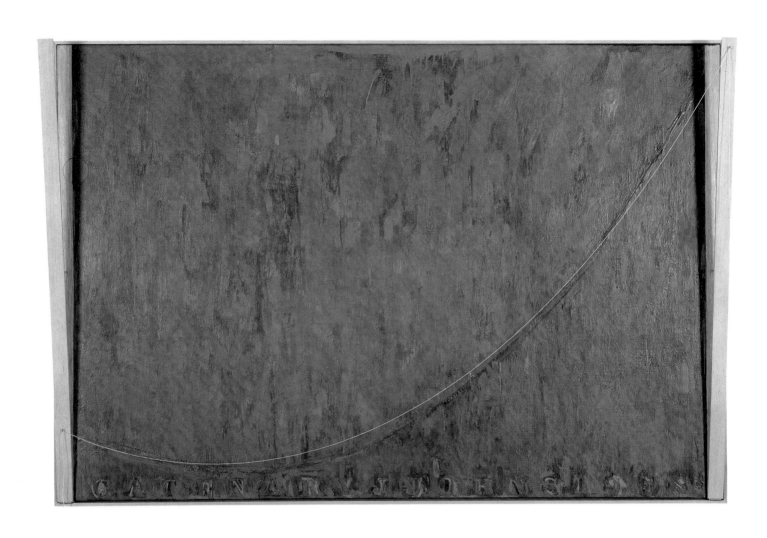

Catenary, 1998
encaustic on canvas with objects (cat. no. 63)

Catenary I, 1999
monotype on paper (cat. no. 65)

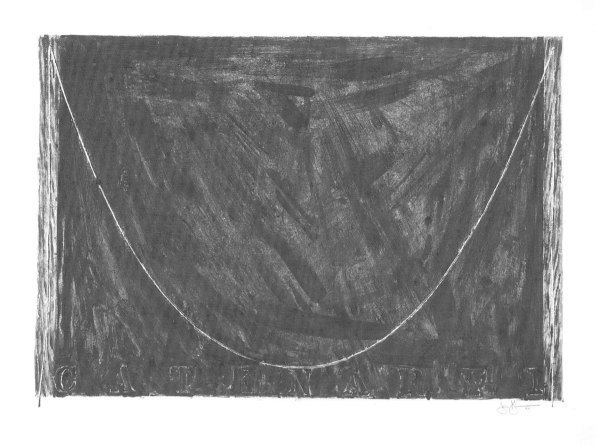

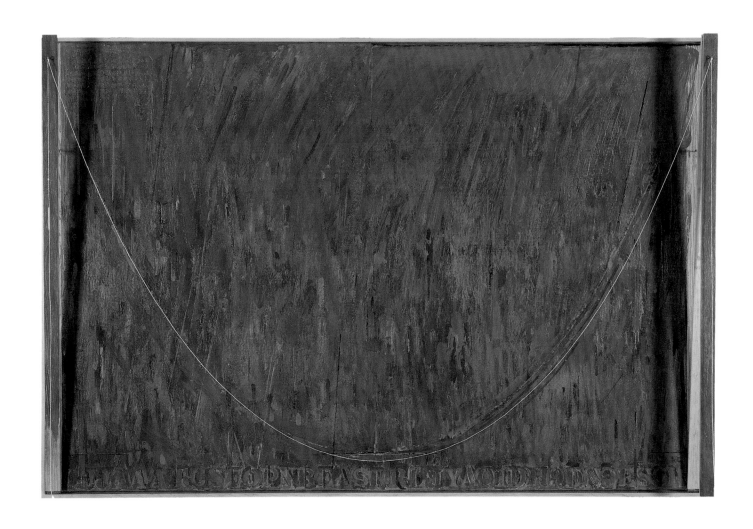

Catenary (Jacob's Ladder), 1999
encaustic on canvas and wood with objects (cat. no. 66)

Catenary (Manet-Degas), 1999
graphite, watercolor, acrylic, ink on paper (cat. no. 67)

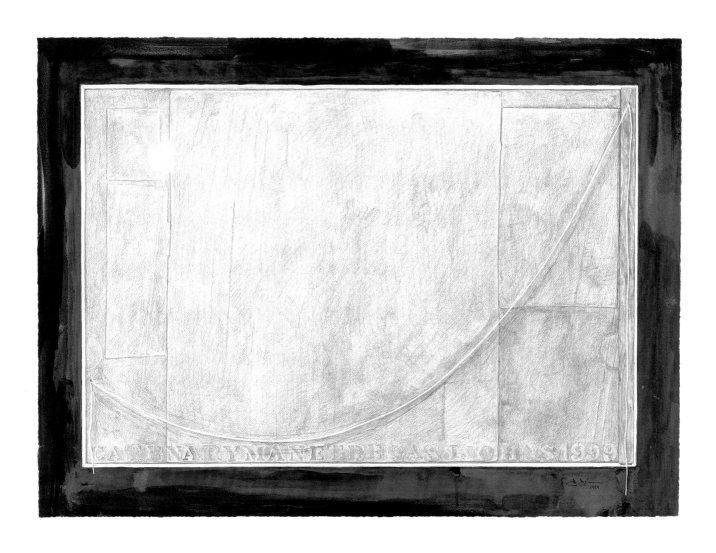

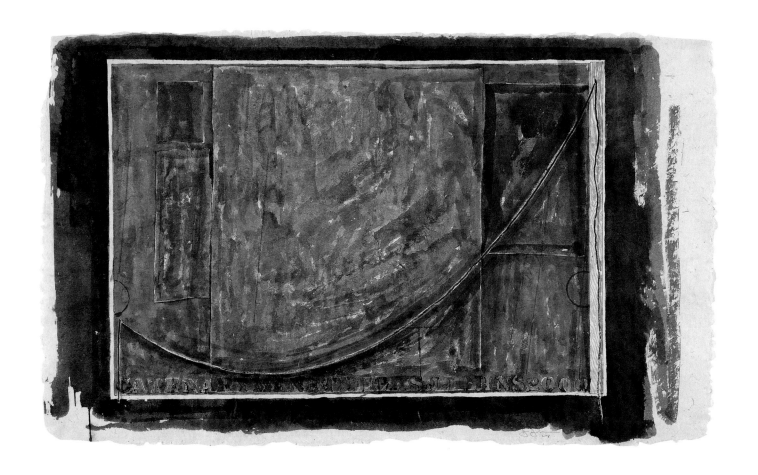

Study for a Painting, 2000
ink on paper (cat. no. 70)

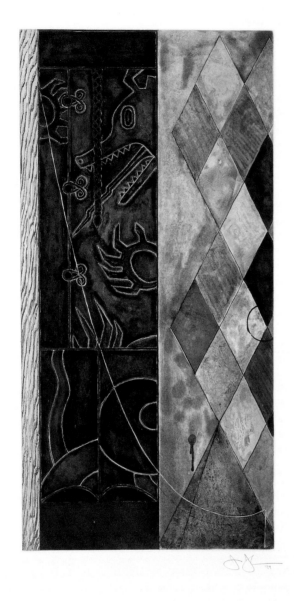

APX

Untitled, 1999
intaglio on paper (cat. no. 69)

Two Costumes, 2000
aquatint, etching, drypoint, chine collé on paper (cat. no. 72)

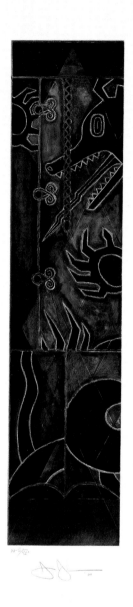

On a fine summer day
the shadows grow darker from the sun
but the shadows aren't as dark as
the white hand reaching into pitch blackness
Only the edge of an American Flag can be seen
but the red and the white of the flag are shining from the
blaze of the sun.
On a sunny afternoon
the stars come out early and glow out for all the world to see
While the man stands there in the sun with nothing on his mind
and nothing he can do but watch the brightness of the stars coming
out early on a summer's day.
The ladder is standing up to the sun and stars but can
only reach to a nearby tree.
The Mona Lisa is staring at nothing but the American Flags surround
her and stay rest to her while a hot summer day flows by.
The sea horse is flying high right to the paintings and patterns in the
painting which are falling to the ground with black and rusty
pans and cups with them.
The arrow is pointing to where we can't see anything
and the man is still standing but his shadow can only be seen.
As summer rolls on
The man is still standing
under a tree branch
while the hot summer
grows on
His shadow is still motionless
and the man can't be seen.

The many colored leaves are dropping to the ground
While the old man meets another man who is running
piteously away from him. Both men don't want
to even look at each other.
But still the leaves are descending to the group
and the many colors of the leaves
are spilling down into the ground.
The ladder breaks like a wishbone right in half
while the two old men are breaking their friendship
lost and never talking to each other again.
The white and pale hand is still reaching for some
pots and glasses but still the hand isn't extending long enough
and the pots and glasses will never be touched.
The arrow points and shoves to the weak
hand while a spoon is collapsing to the ground
separating the two men from hate and despair.
The beautiful painting is also toppling to the ground
and the colors of the painting on the ground
mix with never-ending color of the leaves.
The pattern is engraved to the wall
like the hate that these two men have about each other.
As fall flows mercifully by
Endless pots, glasses and beautiful masterpieces
fall to the ground.
But still the two men standing at opposite corners
will never have peace but hate.
And will never look at each other again.
But really the two men who hate each other
are part of one whole man.

Summer Fall Winter Spring, 2000
4 intaglios on paper; 4 poems by Daniel Shapiro (cat. no. 71)

The snow is coming down now
and the frost is dripping on the painting.
The old man is getting cold and frostbitten
in the huge unbearable snow.
The pure white snow is plopping on his head
while the picture is immovable.
Only a drawing of a white snowman can be
seen through the blizzard of white drifts
on a cold night.
The stars are hiding through the packed snow
and the broken ladder is still there while
snow is drifting into the old man's body
while his life is fading away.
The white hand is scared away from the snow
and turning pure white. While a glitter of the
American Flag is showing, but it is on half mast
today on this cold blizzard. The patterns and paintings
within the painting are getting spotless white flakes.
The snow is crowding up the painting even when the artist
wants to stop glittering mounds of snow pile up his painting.
The sparkle of the snow mounds up on the old man who is standing
there while the sparkle of his life is like a piece of snow flying away.

The dark shadow of a man
is getting pounced on by the
hard rain. While the shadow of
a little boy is as dry as anyone can be.
A white hand reaches out to the colorful
duck while the stars are glittering in the dark-blue sky.
Cups which have two different minds and faces
are flying through the air and sitting on my
windowsill. While the rain is coming down on the
old man and the yellow stars are shining through the night.
The broken ladder is cut in two pieces while a lady could be
either old and shriveled or just an adult staring at something.
The cup falls down and two lives die at once while the old
man is standing in the rain getting cold and the son standing
next to him is dry. The arm extends but can't reach anything
while paintings are getting wet by the plooping of the rain.
The snow is pointing to the son who is still dry while everything
else is getting wet and cold by the rain. The stars are still bright
as can be, the duck is looking at the old man who is getting older and
wetter by the rain. While the cup with two faces dies and the hand
reaches up in the air and the old lady and the adult don't look at
each other and the broken ladder is trying to put its
pieces back together the son is still dry as can be and
the painting is still getting wet.

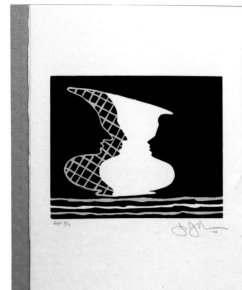

Nurse of terminal birds of blistered lily No black sun aristocrat
fantasy Red rays beat on wet bed and dead palm Caustic powder
Fear pulse Siphon blood to themes in perishing shadow A relic
propped against sunflame Wall wet Red light Mustard-colored
stinking stocking Warm fur Fear pulse Sun on 6 Cheek sweat
on picture glass Sunbaked butterfly crushed Catholic figure with
broken head Vulgar picture curling Fear pulse Metal lock chest
Sun on 6 Sick friend Sunburned boy over bird carcass Black other
room Open legs Shasta murmur Serpent shape Throbbing
tongue Sunbleached ribbon Wet seat Brown blade Fear pulse
Oaxacan pillbox Sun on 6 All my probable signs broiling in a stiff
throat it dries to have life Fear pulse Hearing is a faucet The brutal
is lasting Mouth foam White spots View spun Fear pulse
Thought nausea Sun on 6 Seizure in receding shade It taunts
my throat Quince battered by orange magnets My groin steams
I search for a child's party Dead scent pass I'm moving Iris
embalmed Brutal beam hunts shadow terminals Butterfly fled
the rays False trance of squares Circle burns

Untitled, 2000
linoleum cut on paper (cat. no. 74)

Untitled, 2000
linoleum cut on paper (cat. no. 73)

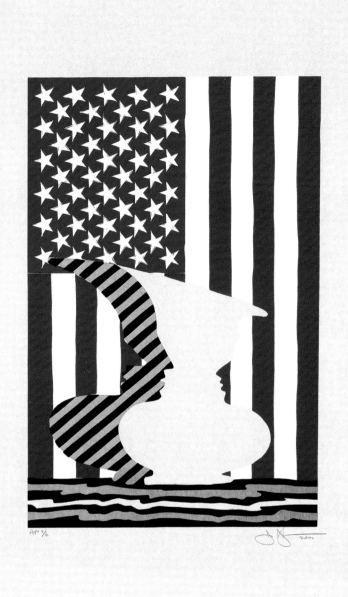

AP 4/10

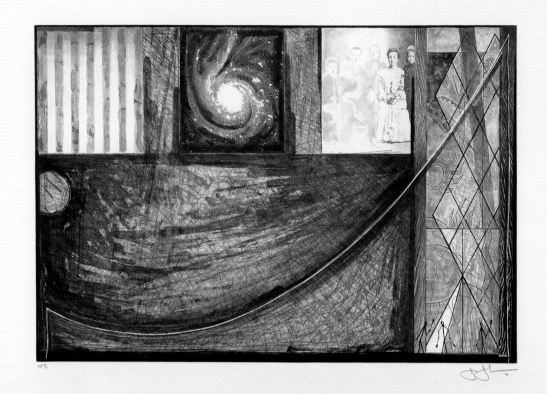

Untitled, 2001
intaglio on paper (cat. no. 75)

Untitled, 2001
intaglio on paper (cat. no. 76)

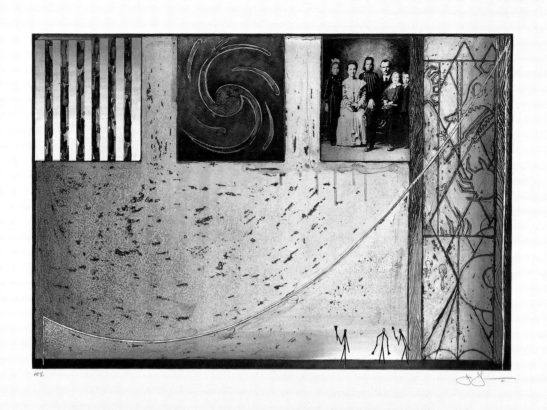

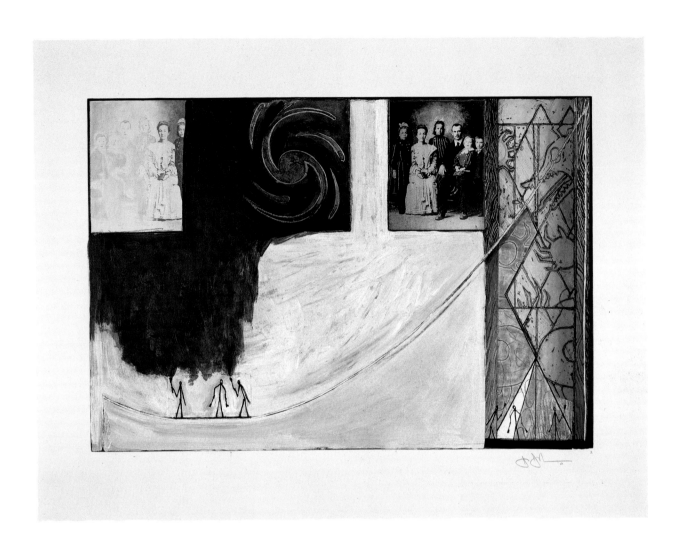

Untitled, 2001
acrylic, collage over intaglio on paper (cat. no. 77)

Untitled, 2001
acrylic, collage over intaglio on paper (cat. no. 78)

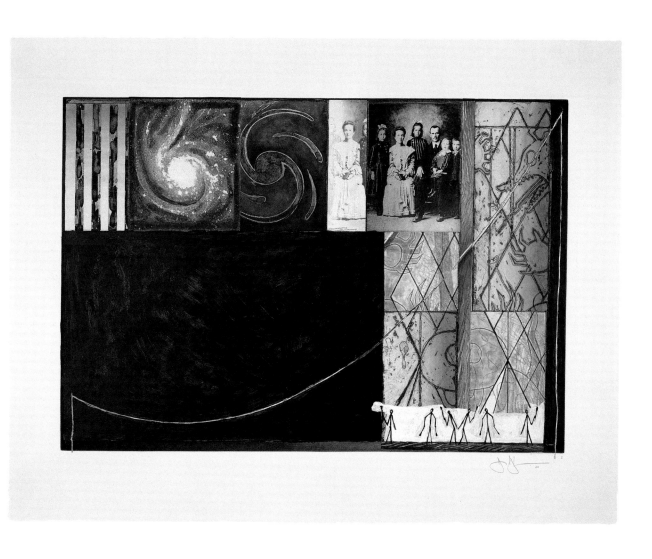

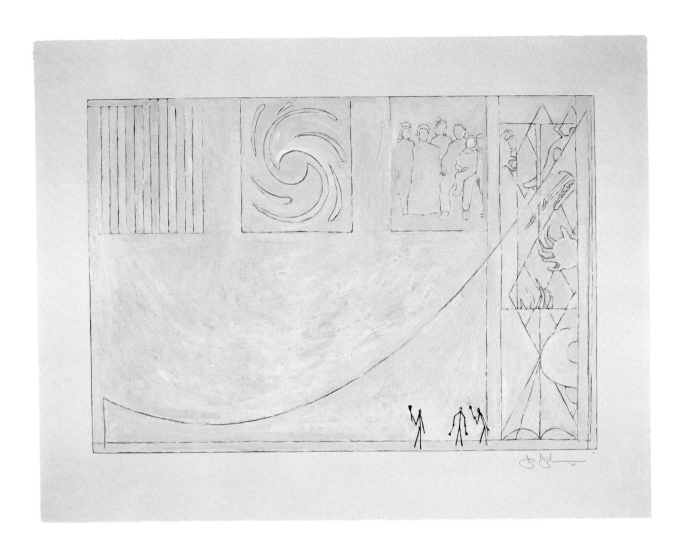

Untitled, 2001
acrylic over intaglio on paper (cat. no. 79)

Untitled, 2001
acrylic over intaglio on paper (cat. no. 80)

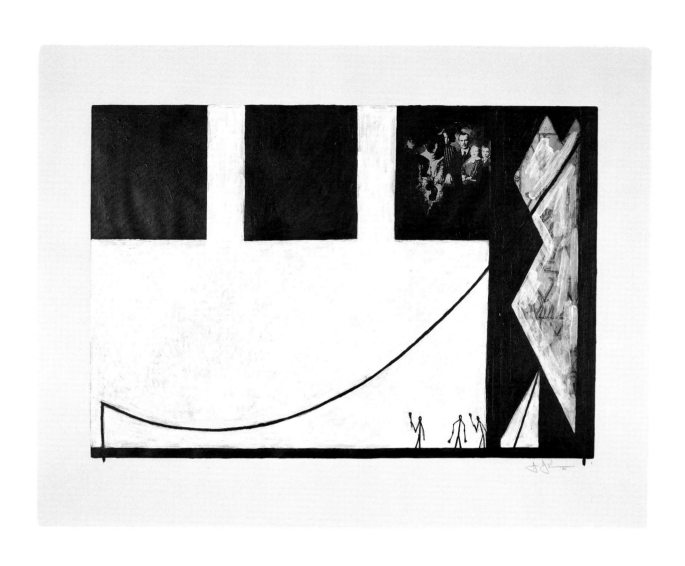

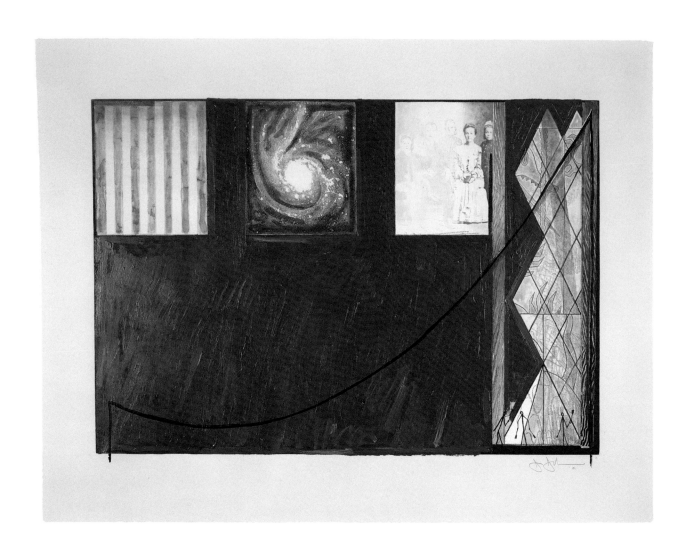

Untitled, 2001
acrylic over intaglio on paper (cat. no. 81)

Untitled, 2001
acrylic over intaglio on paper (cat. no. 82)

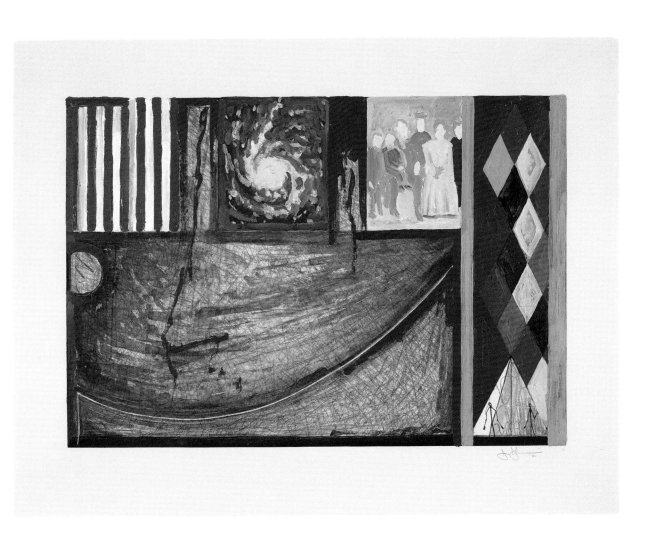

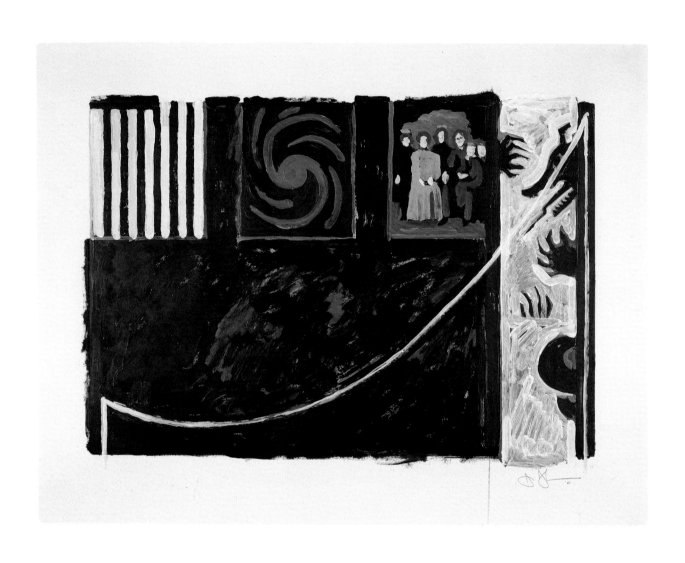

Untitled, 2001
acrylic over intaglio on paper (cat. no. 83)

Untitled, 2001
acrylic over intaglio on paper (cat. no. 84)

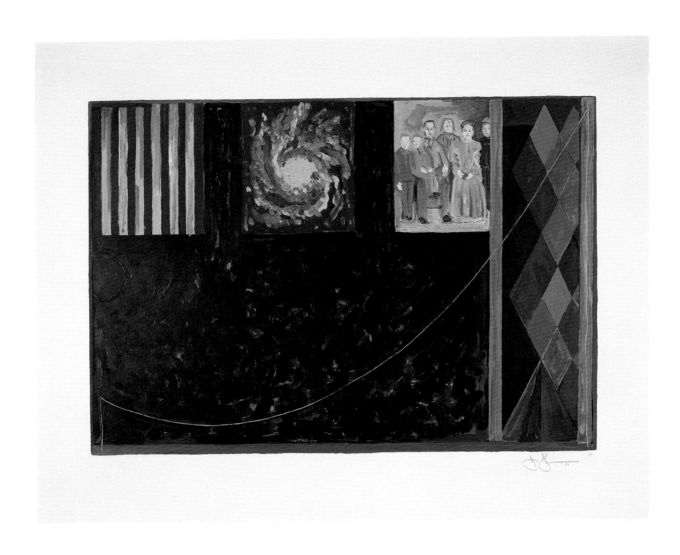

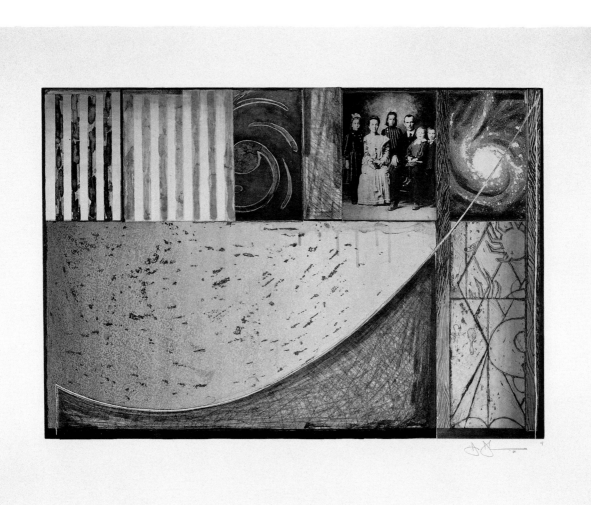

Untitled, 2001
collage over intaglio on paper (cat. no. 85)

Untitled, 2001
collage over intaglio on paper (cat. no. 86)

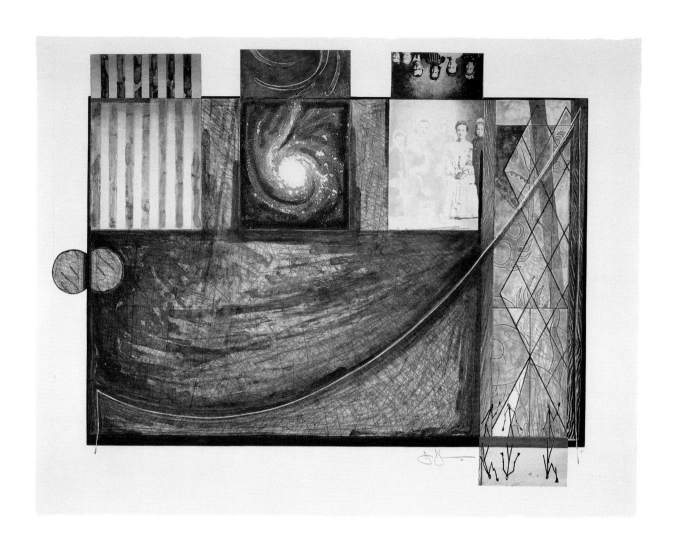

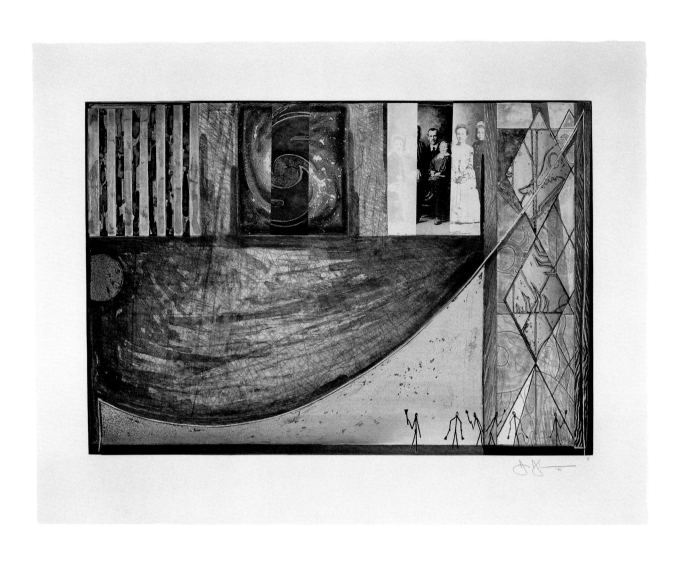

Untitled, 2001
collage over intaglio on paper (cat. no. 87)

Untitled, 2001
collage over intaglio on paper (cat. no. 88)

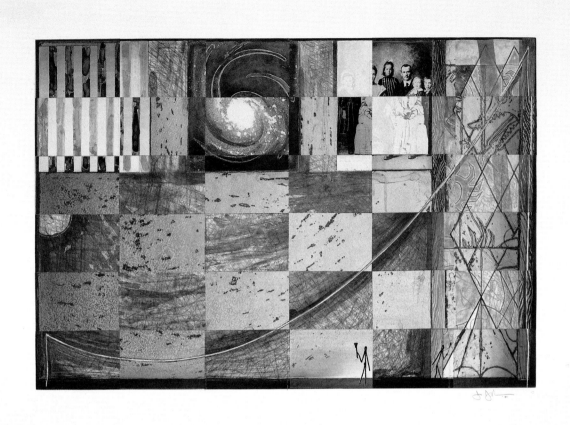

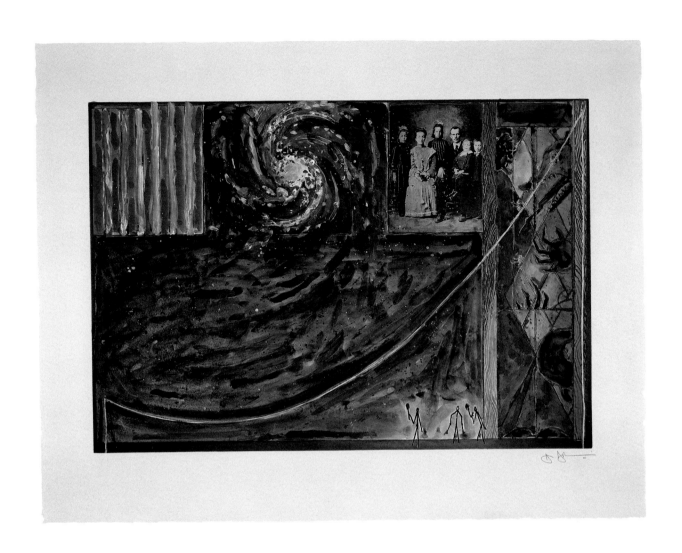

Untitled, 2001
watercolor, gouache over intaglio on paper (cat. no. 89)

Untitled, 2001
watercolor, charcoal on paper (cat. no. 91)

Near the Lagoon, 2002
pastel, watercolor, graphite on paper (cat. no. 92)

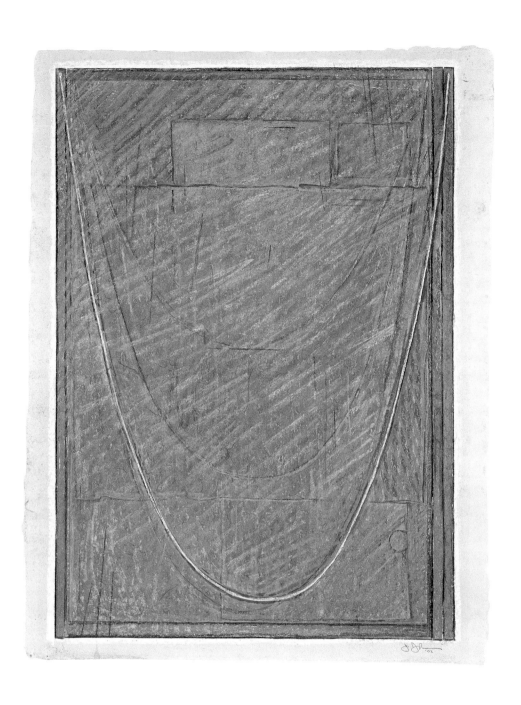

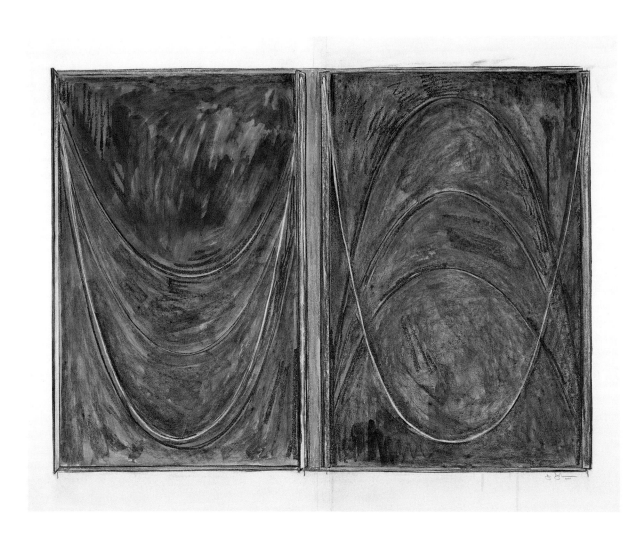

Untitled, 2001
charcoal, graphite, pastel on paper (cat. no. 90)

1 *Untitled*, 1983
charcoal, pastel on paper
19 1/4 x 24 1/4 in. (48.9 x 61.6 cm)
Collection Lenore S. and Bernard A. Greenberg,
Beverly Hills, California

2 *Ventriloquist*, 1983
encaustic on canvas
75 x 50 in. (190.5 x 127 cm)
Collection the Museum of Fine Arts, Houston
Museum purchase with funds provided by the
Agnes Cullen Arnold Endowment Fund

3 *Ventriloquist*, 1984
ink on plastic
34 1/2 x 24 in. (87.63 x 60.96 cm)
Collection the artist

4 *Summer*, 1985
charcoal, chalk on paper
38 3/4 x 24 3/4 in. (98.43 x 62.87 cm)
Collection the artist

5 *Summer*, 1985
charcoal on paper
30 3/8 x 20 3/8 in. (77.15 x 51.75 cm)
Collection the artist

6 *Summer*, 1985
graphite on paper
11 13/16 x 9 1/16 in. (30 x 23.02 cm)
Collection Douglas S. Cramer

7 *Summer*, 1985
intaglio on paper
11 3/4 x 8 1/4 in. (29.9 x 21 cm)
edition 172/326
Published by Arion Press; frontispiece for
Poems by Wallace Stevens
Collection Walker Art Center Library

8 *Summer*, 1985
watercolor on paper
11 3/16 x 9 1/16 in. (28.42 x 23.02 cm)
Private collection, New York

9 *Ventriloquist*, 1985
lithograph on paper
40 3/4 x 27 3/4 in. (103.51 x 70.49 cm)
edition 3/67
Published by ULAE
Collection Walker Art Center, Minneapolis
Gift of Judy and Kenneth Dayton, 1988

10 *The Seasons*, 1986
watercolor, ink on paper
31 3/4 x 23 1/2 in. (80.65 x 59.69 cm)
Collection Barbara and Richard S. Lane

11 *Ventriloquist*, 1986
lithograph on paper
41 3/4 x 29 1/2 in. (106.05 x 74.93 cm)
edition 3/69
Published by ULAE
Collection Walker Art Center, Minneapolis
Gift of Judy and Kenneth Dayton, 1988

12 *Winter*, 1986
aquatint, etching, open-bite on paper
15 3/4 x 12 in. (40.01 x 30.48 cm)
edition 3/34
Published by ULAE
Collection Walker Art Center, Minneapolis
Gift of Judy and Kenneth Dayton, 1988

13 *Winter*, 1986
encaustic on canvas
75 x 50 in. (190.5 x 127 cm)
Private collection

14 *The Seasons (Spring)*, 1987
intaglio on paper
26 1/8 x 19 1/8 in. (66.36 x 48.58 cm)
edition 3/73
Published by ULAE
Collection Walker Art Center, Minneapolis
Gift of Judy and Kenneth Dayton, 1988

15 *The Seasons (Summer)*, 1987
intaglio on paper
26 1/4 x 19 1/8 in. (66.68 x 48.58 cm)
edition 3/73
Published by ULAE
Collection Walker Art Center, Minneapolis
Gift of Judy and Kenneth Dayton, 1988

16 *The Seasons (Fall)*, 1987
intaglio on paper
26 1/4 x 19 1/8 in. (66.68 x 48.58 cm)
edition 3/73
Published by ULAE
Collection Walker Art Center, Minneapolis
Gift of Judy and Kenneth Dayton, 1988

17 *The Seasons (Winter)*, 1987
intaglio on paper
26 1/8 x 19 1/8 in. (66.36 x 48.58 cm)
edition 3/73
Published by ULAE
Collection Walker Art Center, Minneapolis
Gift of Judy and Kenneth Dayton, 1988

18 *Untitled*, 1987
ink on plastic
32 11/16 x 24 in. (83.03 x 60.96 cm)
Collection Dr. Paul and Dorie Sternberg,
Glencoe, Illinois

19 *Untitled*, 1988
carborundum print on paper
29¾ x 22½ in. (75.57 x 57.15 cm)
edition 4/28
Published by Jasper Johns
Collection Walker Art Center, Minneapolis
Gift of the artist, 1989

20 *Untitled*, 1988
carborundum print on paper
35⅝ x 47 in. (90.49 x 119.38 cm)
edition 8/36
Published by Jasper Johns
Collection Walker Art Center, Minneapolis
Gift of the artist, 1989

21 *Untitled*, 1988
encaustic on canvas
38 x 26 in. (96.52 x 66.04 cm)
Collection the artist

22 *Summer*, 1989
intaglio on paper
22½ x 15¼ in. (57.15 x 38.74 cm)
hors commerce 5/16
Collection the artist

23 *The Seasons*, 1989
etching, aquatint on paper
26¾ x 58¼ in. (67.95 x 147.96 cm)
edition 36/54
Published by ULAE
Collection Walker Art Center, Minneapolis
Gift of Dr. and Mrs. Stacy Roback, 1990

24 *The Seasons*, 1989
ink on plastic
23½ x 57 in. (59.69 x 144.78 cm)
Collection Dr. Paul and Dorie Sternberg,
Glencoe, Illinois

25 *The Seasons*, 1989
intaglio, chine collé on paper
46¾ x 32½ in. (118.75 x 82.55 cm)
edition 58/59
Published by ULAE
Collection Walker Art Center, Minneapolis
Gift of Dr. and Mrs. Stacy Roback, 1990

26 *Tracing*, 1989
ink on plastic
36¼ x 31 in. (92.08 x 78.74 cm)
Collection Anne and Anthony d'Offay, London

27 *Tracing*, 1989
ink on plastic
34⁹⁄₁₆ x 26 in. (87.79 x 66.04 cm)
Collection Sarah Taggart

28 *Winter*, 1989
lithograph on paper
14½ x 11 in. (36.83 x 27.94 cm)
edition 24/34
Published by ULAE
Collection Walker Art Center, Minneapolis
Gift of Dr. and Mrs. Stacy Roback, 1988

29 *Green Angel*, 1990
encaustic, sand on canvas
75⅛ x 50³⁄₁₆ x 1¼ in. (190.82 x 127.48 x 3.18 cm)
Collection Walker Art Center, Minneapolis
Anonymous gift in honor of Martin and Mildred
Friedman, 1990

30 *The Seasons*, 1990
intaglio on paper
50⅜ x 44⅝ in. (127.95 x 113.35 cm)
edition 16/50
Published by ULAE
Collection Walker Art Center, Minneapolis
Gift of Martha and John Gabbert, 1990

31 *Untitled*, 1990
ink, watercolor, pencil on paper
31 x 22½ in. (78.74 x 57.15 cm)
Collection the artist

32 *Untitled*, 1990
lithograph on paper
10½ x 8 in. (26.67 x 20.32 cm)
artist's proof 3/50; edition of 250
Published by Gemini G.E.L.
Collection Walker Art Center, Minneapolis
Gift of the artist, 1991

33 *Untitled*, 1990
pastel on paper
28 x 21 in. (71.12 x 53.34 cm)
Collection the artist

34 *Untitled*, 1990
watercolor, charcoal, chalk, pencil on paper
30⅛ x 22⅛ in. (67.31 x 48.26 cm)
Collection Barbaralee Diamonstein-Spielvogel and
Carl Spielvogel, New York

35 *Untitled*, 1990
watercolor, pencil on paper
28 x 19⅜ in. (71.12 x 49.21 cm)
Collection the artist

36 *Untitled*, 1990
watercolor, pencil on paper
31 x 22¾ in. (78.74 x 57.79 cm)
Collection the artist

37 *Ventriloquist*, 1990
lithograph on paper
40 x 26¾ in. (101.6 x 67.95 cm)
artist's proof 7/7; edition of 70
Published by ULAE
Collection Walker Art Center, Minneapolis
Gift of the artist, 1990

38 *Green Angel*, 1991
etching on paper
31 x 22⅝ in. (78.74 x 57.47 cm)
artist's proof 3/13; edition of 46
Published by ULAE
Collection Walker Art Center, Minneapolis
Gift of the artist, 1991

39 *Summer (Blue)*, 1991
lithograph on paper
16¼ x 11¼ in. (41.28 x 28.58 cm)
artist's proof 3/19; edition of 225
Published by Brooke Alexander Editions, New York
Collection Walker Art Center, Minneapolis
Gift of the artist, 1992

40 *Untitled*, 1991
encaustic on canvas
60 x 40 in. (152.4 x 101.6 cm)
Collection Greenville County Museum of Art,
Greenville, South Carolina
Museum purchase from the Arthur and Holly
Magill Fund

41 *Untitled*, 1991
ink on plastic
34 x 45 in. (86.36 x 114.3 cm)
Collection Philip and Beatrice Gersh,
Beverly Hills, California

42 *Untitled*, 1991
oil on canvas
48¼ x 60¼ in. (122.56 x 153.04 cm)
Collection Larry Gagosian, New York

43 *Untitled*, 1992
etching, aquatint on paper
43½ x 52⁹⁄₁₆ in. (110.49 x 133.51 cm)
artist's proof 3/15; edition of 50
Published by ULAE
Collection Walker Art Center, Minneapolis
Gift of the artist, 1992

44 *Untitled*, 1992
graphite on paper
27¼ x 41¼ in. (69.22 x 104.78 cm)
Private collection, Houston

45 *Untitled*, 1992
lithograph on paper
38 7/8 x 31 1/4 in. (98.74 x 79.38 cm)
artist's proof 5/12; edition of 72
Published by Gemini G.E.L.
Collection Walker Art Center, Minneapolis
Gift of the artist, 1993

46 *Untitled*, 1992
lithograph on paper
39 x 31 1/4 in. (99.06 x 79.38 cm)
artist's proof 5/12; edition of 74
Published by Gemini G.E.L.
Collection Walker Art Center, Minneapolis
Gift of the artist, 1993

47 *After Holbein*, 1993
lithograph on paper
25 3/4 x 18 5/8 in. (65.41 x 47.31 cm)
artist's proof 3/9; edition of 48
Published by ULAE
Collection Walker Art Center, Minneapolis
Gift of the artist, 1993

48 *After Holbein*, 1993
lithograph on paper
23 1/2 x 22 1/4 in. (59.69 x 56.52 cm)
artist's proof 3/14; edition of 48
Published by ULAE
Collection Walker Art Center, Minneapolis
Gift of the artist, 1993

49 *After Holbein*, 1993
lithograph on paper
22 3/8 x 30 1/8 in. (56.83 x 76.52 cm)
artist's proof 3/40; edition of 150
Published by Artists against Torture Association
Collection Walker Art Center, Minneapolis
Gift of the artist, 1993

50 *Untitled (after Holbein)*, 1993
pencil on paper
28 1/8 x 18 1/4 in. (71.44 x 46.36 cm)
Private collection
Courtesy Margo Leavin Gallery, Los Angeles

51 *After Holbein*, 1994
lithograph on paper
32 1/2 x 25 in. (82.55 x 63.5 cm)
artist's proof 3/9; edition of 42
Published by ULAE
Collection Walker Art Center, Minneapolis
Gift of the artist, 1994

52 *Untitled*, 1994
lithograph on paper
36 1/4 x 30 1/2 in. (92.08 x 77.47 cm)
artist's proof 3/22; edition of 75
Published by ULAE
Collection Walker Art Center, Minneapolis
Gift of the artist, 1994

53 *Untitled*, 1994
pastel, charcoal on paper
27 1/4 x 13 3/4 in. (69.22 x 34.93 cm)
Collection Judy and Kenneth Dayton, Minneapolis

54 *Untitled*, 1995
lithograph on paper
41 3/8 x 53 1/4 in. (105.09 x 135.26 cm)
artist's proof 3/11; edition of 49
Published by ULAE
Collection Walker Art Center, Minneapolis
Gift of the artist, 1996

55 *Untitled*, 1995
mezzotint on paper
26 x 18 7/8 in. (66.04 x 47.94 cm)
artist's proof 3/9; edition of 37
Published by ULAE
Collection Walker Art Center, Minneapolis
Gift of the artist, 1995

56 *Untitled*, 1995
mezzotint on paper
25 7/8 x 18 7/8 in. (65.72 x 47.94 cm)
artist's proof 3/10; edition of 39
Published by ULAE
Collection Walker Art Center, Minneapolis
Gift of the artist, 1995

57 *Untitled*, 1995
mezzotint on paper
29 3/4 x 22 1/2 in. (75.57 x 57.15 cm)
artist's proof 3/10; edition of 48
Published by ULAE
Collection Walker Art Center, Minneapolis
Gift of the artist, 1995

58 *Face with Watch*, 1996
intaglio on paper
42 x 31 7/8 in. (106.68 x 80.96 cm)
artist's proof 3/12; edition of 50
Published by ULAE
Collection Walker Art Center, Minneapolis
Gift of the artist, 1998

59 *Untitled*, 1996
monotype on paper
38 3/4 x 24 1/2 in. (98.43 x 62.23 cm)
Collection Anne Marie Martin

60 *Untitled*, 1996
monotype on paper
42 x 23 1/2 in. (106.68 x 59.69 cm)
Collection the artist

61 *Green Angel 2*, 1997
intaglio on paper
47 7/8 x 24 3/4 in. (121.6 x 62.87 cm)
artist's proof 3/13; edition of 58
Published by ULAE
Collection Walker Art Center, Minneapolis
Gift of the artist, 1998

62 *Untitled*, 1997
intaglio on paper
20 x 25 3/4 in. (50.8 x 65.41 cm)
artist's proof 3/15; edition of 49
Published by ULAE
Collection Walker Art Center, Minneapolis
Gift of the artist, 1998

63 *Catenary*, 1998
encaustic on canvas with objects
44 x 66 x 5 3/16 in. (111.76 x 167.64 x 13.18 cm)
Collection Dr. Paul and Dorie Sternberg,
Glencoe, Illinois

64 *Untitled*, 1998
etching on paper
29 13/16 x 22 in. (75.72 x 55.88 cm)
artist's proof 3/30; edition of 75
Published by The Estate Project for
Artists with AIDS
Collection Walker Art Center, Minneapolis
Gift of the artist, 2000

65 *Catenary I*, 1999
monotype on paper
27 x 37 in. (68.58 x 93.98 cm)
Collection the artist

66 *Catenary (Jacob's Ladder)*, 1999
encaustic on canvas and wood with objects
38 x 57 1/4 x 5 1/4 in. (96.52 x 145.42 x 13.34 cm)
Collection the artist

67 *Catenary (Manet-Degas)*, 1999
graphite, watercolor, acrylic, ink on paper
24 3/8 x 33 5/8 in. (61.91 x 85.41 cm)
Collection Whitney Museum of American Art,
New York
Gift of the American Contemporary Art Foundation,
Inc., Leonard A. Lauder, President

68 *Untitled*, 1999
intaglio on paper
27 1/4 x 19 3/4 in. (69.22 x 50.17 cm)
artist's proof 3/6; edition of 37
Published by Jasper Johns
Collection Walker Art Center, Minneapolis
Gift of the artist, 2000

69 *Untitled*, 1999
intaglio on paper
29 3/8 x 17 5/8 in. (74.61 x 44.77 cm)
artist's proof 3/11; edition of 46
Published by ULAE
Collection Walker Art Center, Minneapolis
Gift of the artist, 2000

70 *Study for a Painting*, 2000
ink on paper
24 x 40⅜ in. (60.96 x 102.55 cm)
Collection the artist

71 *Summer Fall Winter Spring*, 2000
4 intaglios on paper; 4 poems by Daniel Shapiro
25½ x 35½ in. each of 4 open (64.77 x 90.17 cm)
hors commerce; edition of 4
Collection the artist

72 *Two Costumes*, 2000
aquatint, etching, drypoint, chine collé on paper
30⅛ x 12¼ in. (76.52 x 31.12 cm)
artist's proof III/VIII; edition of 49
Published by Jasper Johns
Collection Walker Art Center, Minneapolis
Gift of the artist, 2001

73 *Untitled*, 2000
linoleum cut on paper
22¾ x 17 in. (57.79 x 43.18 cm)
artist's proof 4/6; edition of 38
Published by Jasper Johns
Collection Walker Art Center, Minneapolis
Gift of the artist, 2001

74 *Untitled*, 2000
linoleum cut on paper
9½ x 12½ in. (24.13 x 31.75 cm)
artist's proof 3/7; edition of 26
Published by Z Press in *Sun on 6*,
with a poem of the same name by Jeff Clark
Collection Walker Art Center, Minneapolis
Gift of the artist, 2002

75 *Untitled*, 2001
intaglio on paper
26 x 33¾ in. (66.04 x 85.73 cm)
artist's proof 3/11; edition of 46
Published by ULAE
Collection Walker Art Center, Minneapolis
Gift of the artist, 2001

76 *Untitled*, 2001
intaglio on paper
26 x 33¹³⁄₁₆ in. (66.04 x 85.88 cm)
artist's proof 3/11; edition of 46
Published by ULAE
Collection Walker Art Center, Minneapolis
Gift of the artist, 2001

77 *Untitled*, 2001
acrylic, collage over intaglio on paper
24½ x 32⅛ in. (62.23 x 81.6 cm)
Collection the artist

78 *Untitled*, 2001
acrylic, collage over intaglio on paper
24½ x 32⅛ in. (62.23 x 81.6 cm)
Collection the artist

79 *Untitled*, 2001
acrylic over intaglio on paper
24½ x 32⅛ in. (62.23 x 81.6 cm)
Collection the artist

80 *Untitled*, 2001
acrylic over intaglio on paper
24½ x 32⅛ in. (62.23 x 81.6 cm)
Collection the artist

81 *Untitled*, 2001
acrylic over intaglio on paper
24½ x 32⅛ in. (62.23 x 81.6 cm)
Collection the artist

82 *Untitled*, 2001
acrylic over intaglio on paper
24½ x 32⅛ in. (62.23 x 81.6 cm)
Collection the artist

83 *Untitled*, 2001
acrylic over intaglio on paper
24½ x 32⅛ in. (62.23 x 81.6 cm)
Collection the artist

84 *Untitled*, 2001
acrylic over intaglio on paper
24½ x 32⅛ in. (62.23 x 81.6 cm)
Collection the artist

85 *Untitled*, 2001
collage over intaglio on paper
24½ x 32⅛ in. (62.23 x 81.6 cm)
Collection the artist

86 *Untitled*, 2001
collage over intaglio on paper
24½ x 32⅛ in. (62.23 x 81.6 cm)
Collection the artist

87 *Untitled*, 2001
collage over intaglio on paper
24½ x 32⅛ in. (62.23 x 81.6 cm)
Collection the artist

88 *Untitled*, 2001
collage over intaglio on paper
24½ x 32⅛ in. (62.23 x 81.6 cm)
Collection the artist

89 *Untitled*, 2001
watercolor, gouache over intaglio on paper
24½ x 32⅛ in. (62.23 x 81.6 cm)
Collection the artist

90 *Untitled*, 2001
charcoal, graphite, pastel on paper
36⅜ x 46¾ in. (92.39 x 118.75 cm)
Collection the artist

91 *Untitled*, 2001
watercolor, charcoal on paper
31½ x 24⅞ in. (80.01 x 63.18 cm)
Collection the artist

92 *Near the Lagoon*, 2002
pastel, watercolor, graphite on paper
31½ x 24¾ in. (80.01 x 62.87 cm)
Collection the artist

All works by Jasper Johns © Jasper Johns/
Licensed by VAGA, New York, NY

Universal Limited Art Editions is cited as ULAE.

Selected Bibliography

Armstrong, Elizabeth, et al. *Jasper Johns: Printed Symbols*. exh. cat. Minneapolis: Walker Art Center, 1990.

Baker, Kenneth. "Jasper Johns: San Francisco Museum of Modern Art." *ARTnews* 99, no. 2 (February 2000): 166.

Bernard, April, and Mimi Thompson. "Johns on . . ." *Vanity Fair* 47, no. 2 (February 1984): 65.

Bernstein, Roberta. *Jasper Johns: The Seasons*. exh. cat. New York: Brooke Alexander Editions, 1991.

Bertozzi, Barbara. *The Seasons: Jasper Johns*. Milan: Charta, 1996.

Brundage, Susan, ed. *Jasper Johns—35 Years—Leo Castelli*. Text by Judith Goldman. New York: Leo Castelli Gallery, 1993

Brundage, Susan, and Susan Lorence. *Technique and Collaboration in the Prints of Jasper Johns*. New York: Leo Castelli Gallery, 1996.

Castleman, Riva. *Jasper Johns: A Print Retrospective*. exh. cat. New York: Museum of Modern Art, 1986.

Cotter, Holland. "Still Producing Riddles, Still Profoundly Opaque." *New York Times*, March 24, 2000, sec. E, 38.

Craft, Catherine. "New Haven and Dallas: Recent Works by Jasper Johns." *Burlington Magazine* 142, no. 1166 (May 2000): 329–330.

Crichton, Michael. *Jasper Johns*. New York: Harry N. Abrams and Whitney Museum of American Art, 1994.

Fine, Ruth E. "The Search for Subject: Jasper Johns." *Gemini G.E.L.: Art and Collaboration*, 161–177. New York: Abbeville Press, 1984.

Francis, Richard. "Disclosures." *Art in America* 72, no. 8 (September 1984): 196–203.

Garrels, Gary, ed. *Jasper Johns: New Paintings and Works on Paper*. exh. cat. San Francisco: San Francisco Museum of Modern Art, 1999.

Huerta, Benito. "Falling Eyes: The Bridge between the Physical and the Metaphysical." *ArtLies: Texas Art Journal* 27 (Summer 2000): 21–23.

Jasper Johns. exh. cat. Stockholm: Heland Wetterling Gallery, 1991

Jasper Johns: The Seasons. exh. cat. Text by Judith Goldman. New York: Leo Castelli Gallery, 1987.

Jasper Johns: Loans from the Artist. exh. cat. Text by Robert Rosenblum. Riehen/Basel: Foundation Beyeler, 1997.

Johns, Jasper. "Jasper Johns." Interview by Mark Rosenthal. *Artists at Gemini G.E.L.: Celebrating the 25th Year*. New York: Harry N. Abrams, 1993.

Johnston, Jill. "Jasper Johns' Artful Dodging." *ARTnews* 87, no. 9 (November 1988): 156–159.

_____. *Jasper Johns: Privileged Information*. New York: Thames & Hudson, 1996.

_____. "Tracking the Shadow." *Art in America* 75, no. 10 (October 1987): 128–143.

_____. "Trafficking with X." *Art in America* 79, no. 3 (March 1991): 102–111.

Knight, Christopher. "One for All" in "Split Decisions: Jasper Johns in Retrospect." *Artforum International* 35, no. 1 (September 1996): 79–85, 125.

Krauss, Rosalind E. "Whole in Two" in "Split Decisions: Jasper Johns in Retrospect." *Artforum International* 35, no. 1 (September 1996): 79–84.

Orton, Fred. *Figuring Jasper Johns*. Cambridge, Mass.: Harvard University Press, 1994.

Perl, Jed. "Jasper's Seasons." *New Criterion* 5, no. 8 (June 1987): 56–58.

The Prints of Jasper Johns 1993: A Catalogue Raisonné. Text by Richard Field. West Islip, NY: ULAE, 1994

Ratcliff, Carter. "The Inscrutable Jasper Johns." *Vanity Fair* 46, no. 10 (December 1983): 61–64.

Rose, Barbara. "Jasper Johns: The Seasons." *Vogue* 177, no. 1 (January 1987): 193–199, 259–260.

Rosenthal, Mark. *Jasper Johns Drawings*. Houston: Menil Foundation, 2003.

_____. *Jasper Johns: Work since 1974*. exh. cat. Philadelphia: Philadelphia Museum of Art, and New York: Thames & Hudson, 1988.

Rosenthal, Nan, et al. *The Drawings of Jasper Johns*. exh. cat. Washington, D.C.: National Gallery of Art, and New York: Thames & Hudson, 1990.

Smith, Roberta. "When What Masters Do Is Not What They Say." *New York Times*, January 14, 2000, sec. B, 46.

Varnedoe, Kirk. *Jasper Johns: A Retrospective*. exh. cat. New York: Museum of Modern Art, 1996.

_____, ed. *Jasper Johns: Writings, Sketchbook Notes, Interviews*. New York: Museum of Modern Art, 1996.

Welish, Marjorie. "Frame of Mind: Interpreting Jasper Johns." *Art Criticism* 3, no. 2 (1987): 71–87.

Yau, John. "Enter the Dragon." *ARTnews* 98, no. 8 (September 1999): 124–125.

_____. "Proofs Positive: The Master Works." *ARTnews* 87, no. 7 (September 1988): 104–106.

_____. "Target Jasper Johns." *Artforum International* 24, no. 4 (December 1985): 80–84.

_____. *The United States of Jasper Johns*. Cambridge, Mass.: Zoland Books, 1996.

Reproduction Credits

All works by Jasper Johns ©Jasper Johns/Licensed by VAGA, New York, NY

Preference without a Cause
Richard Shiff

fig. 1 Courtesy Whitney Museum of American Art, New York; Photo by Geoffrey Clements

fig. 3 Courtesy The Geis Archives, New York

figs. 5, 7–8, 12 Courtesy Jasper Johns; Photo ©Dorothy Zeidman, New York

fig. 6 ©2003 Estate of Pablo Picasso/Artists Rights Society (ARS), New York; Courtesy Réunion des Musées Nationaux/Art Resource, New York; Photo: J. G. Berizzi

fig. 9 ©2003 Estate of Pablo Picasso/Artists Rights Society (ARS), New York; Courtesy Réunion des Musées Nationaux/Art Resource, New York; Photo: P. Bernard

fig. 10 Courtesy Rheinisches Bildarchiv, Cologne, Germany

fig. 11 Courtesy Yale University Art Gallery, New Haven, Connecticut

fig. 12 Photo ©Ugo Mulas Estate, Milan; All rights reserved

fig. 13 Courtesy Matthew Marks Gallery, New York

fig. 14 Photo ©Dorothy Zeidman, New York

What Do You See? Jasper Johns' Green Angel
Joan Rothfuss

figs. 1, 9, 13 Courtesy Jasper Johns; Photos: Jim Strong, Inc., New York

figs. 2–3, 6 ©Musée d'Unterlinden, Colmar, France; Photos by O. Zimmermann

figs. 4, 7–8, 10–11, 16 Courtesy Jasper Johns; Photos ©Dorothy Zeidman, New York

figs. 5, 12, 15, 17 Photos: Glenn Halvorson

fig. 14 Courtesy Jasper Johns

Three Academic Ideas
Victor I. Stoichita

figs. 1, 2, 8, 10 (cat. no. 24) Courtesy Jasper Johns; Photo ©Dorothy Zeidman, New York

fig. 3 Photo: Glenn Halvorson

fig. 9 Courtesy Dr. Paul and Dorie Sternberg, Glencoe, Illinois

fig. 11 Mark Lancaster

fig. 12 Courtesy University Libraries of Notre Dame, Rare Books and Manuscripts, Notre Dame, Indiana

fig. 13 ©2003 Estate of Pablo Picasso/Artists Rights Society (ARS), New York; Photo: J. G. Berizzi

fig. 14 Courtesy the Pierpont Morgan Library, New York; Photo: David A. Loggie

fig. 15 Courtesy Jasper Johns

fig. 17 Courtesy Séminaire d'histoire de l'art, Fribourg, Switzerland

Plates

cat. no. 1 Courtesy Mary Boone Gallery, New York; Photo ©Zindman/Fremont

cat. no. 2 ©Museum of Fine Arts, Houston

cat. nos. 3–5, 10, 13, 18, 21, 44, 53, 60, 65–66, 68–71, 77–92 Courtesy Jasper Johns; Photos ©Dorothy Zeidman, New York

cat. no. 6 Courtesy Douglas S. Cramer, Roxbury, Connecticut

cat. nos. 7, 19–20, 28, 32, 59, 74 Photos: Cameron Wittig

cat. no. 8 Courtesy private collection, New York; Photo by Oren Slor, New York

cat. nos. 9, 11–12, 14–17, 23, 25, 29–30, 37–39, 43, 45–49, 51–52, 54–58, 61–62, 64, 72–73, 75–76 Photos: Glenn Halvorson

cat. no. 22 Courtesy Universal Limited Art Editions, Inc. (ULAE), West Islip, New York

cat. nos. 24, 63 Courtesy Dr. Paul and Dorie Sternberg, Glencoe, Illinois

cat. no. 26 Courtesy Anthony and Anne d'Offay, London; Photo: Prudence Cuming Associates Limited

cat. nos. 27, 31, 33–36 Courtesy Jasper Johns; Photos: Jim Strong, Inc.

cat. no. 40 Courtesy Greenville County Museum of Art; Photo ©Dorothy Zeidman

cat. nos. 41, 50 Courtesy Margo Leavin Gallery, Los Angeles

cat. no. 42 Courtesy Gagosian Gallery, New York

cat. no. 67 Courtesy Whitney Museum of American Art, New York; Photo: Sheldan C. Collins